ALLAN McCOLLUM

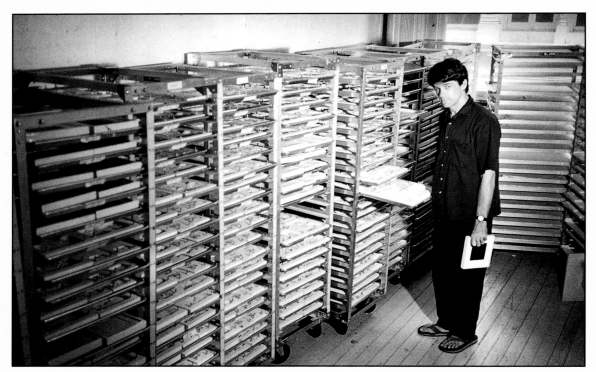

Allan McCollum in his studio, New York City, 1989.
Photo: Sabine Matthes.

ALLAN McCOLLUM

Interview by Thomas Lawson

Published by
A.R.T. Press, Los Angeles
1996

Allan McCollum
Editor: William S. Bartman
Copyeditor: Patricia Draher, Seattle
Designer: Judith Lausten, Lausten/Cossutta Design, Los Angeles
Printer: Mondadori, Verona, Italy

Distributed by Distributed Art Publishers
636 Broadway, Room 1208
New York, New York 10012
800-338-2665

ISBN 0-923183-14-0

Cover: *The Dog from Pompei,* 1991, polymer-modified Hydrocal,
20 x 21 x 21 inches. Photo: Eric Baum

This publication was made possible in part by the generous support
of The National Endowment for the Arts Design Arts Program,
The LLWW Foundation, The Foundation for Expanding Horizons,
The Norton Family Foundation, our Library Fellows, which include
The Lannan Foundation, Ruth and Jake Bloom, The Bartman
Foundation, and The Ganz Foundation. We would also like to thank
many individual contributors whose support has made our publish-
ing efforts a continued success.

We would like to pay special thanks to Agnes Gund and Marion
Boulton Stroud for their ongoing support and encouragement of this
and other A.R.T. Press projects.

Art Resources Transfer, Inc. (A.R.T. Press), is a nonprofit,
tax-exempt organization that was founded in 1987 to publish books
with artists in which the artist plays the central role in the
development and production of the actual book.

A.R.T. Press books are based on an in-depth collaboration
between artist, designer, and editor. We establish access to
contemporary art books in underserved communities and provide
additional oppotunities for emerging artists.

CONTENTS

THIS INTERVIEW IS DRAWN FROM TWO CONVERSATIONS BETWEEN ALLAN McCOLLUM AND THOMAS LAWSON: ONE IN NEW YORK CITY ON 23 JUNE 1992, THE OTHER IN LOS ANGELES ON 15 NOVEMBER 1992.

(a)

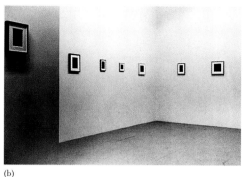

(b)

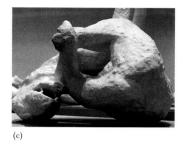

(c)

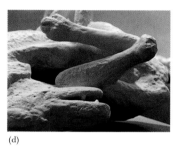

(d)

(a) *Surrogate Painting* (from television), 1981–83 (b) *Surrogate Paintings*, 1980–81, acrylic on wood and museum board. Photo: Mary Ellen Latella (c) and (d) *The Dog from Pompei*, 1991, polymer-modified Hydrocal, 20 x 21 x 21 inches each. Installation site: John Weber Gallery, New York City.

Tom: In many of the interviews you've given, you sound very angry about culture, about the way the idea of the museum operates and what your feelings are when you go into a museum. You want to know who paid for this, who cares about that. There is a real sense of alienation. It seems to me there's a lot of anger in the way you talk about your work. And until recently, I would say that you have been concerned with developing abstract methods of drumming out that anger.

Allan: I don't know that I agree with you exactly. Maybe you're right: in previous interviews I've expressed some anger at the way we always tend to define culture in terms of the interests of some privileged group. But I don't know if you can always necessarily infer that that's what my artwork is about. I think that's wrong. Maybe I'm too chatty in interviews, or maybe I dwell too much on how I feel about things in general when I should be talking more specifically about the ideas related to my work.

Tom: So you want to keep your feelings as a person in the world separate from your thoughts as a working artist?

Allan: No, of course not [laughs]. My work is *always* about my feelings, but I also seem to always design my projects so that they invite wider cultural analyses. I do want my work to suggest a larger picture of the way we experience culture and participate in it. I like to ask questions about how society creates objects, and what those objects mean. But when I speak of society and culture, I'm obviously speaking from a personal, biased point of view.

Back in the seventies, with the *Surrogate Paintings*, for instance, I was trying to make objects that made it easier for me to explore my own relationship with paintings in general. But I assumed that my relationship with paintings was similar to everybody else's. I think you could talk about each series that I've done in terms that would sound angry or fearful, but you could also use terms that would sound exuberant or playful, and so forth, or even humorous, ironic, or silly. So I want to challenge your statement a bit. At the same time, there's something about what you're saying that is true. Lately I have been trying to be more constructive than I used to be, to explore art making as something that might be *good* for something!

Tom: Well, what we're talking about, I think, is the critical perception of your work, not necessarily what you think of your work. One of the reasons to look at what you have been doing is to understand it in the context of a progressive, thinking-through, abstract method of art making.

Allan: There's a reduction.

Tom: A reductionism and an antirepresentational position—for example, with the *Surrogates,* you use the blank center of the issue of representation. But the real difference with the more recent works—the cast *Dog from Pompei* and the dinosaur bones—is that they bring representation right up to the surface. A lot of the discussion of your earlier work has to do with framing—framing created by the pieces or by the institution, the context of exhibition, all that kind of thing. Pompeii

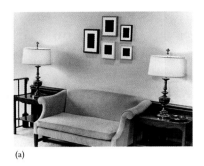

(a)

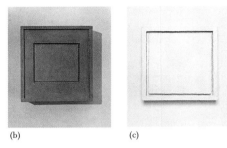

(b) (c)

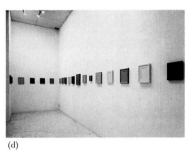

(d)

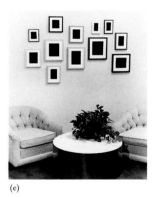

(e)

(a) *Surrogate Paintings*, 1980–81, acrylic on wood and museum board. Installation site: Paine Webber corporate waiting area, New York City, 1981. Photo: Mary Ellen Latella (b) *Surrogate Painting*, 1978, acrylic and enamel on wood and museum board, 6 ⅜ x 5 ⁹⁄₁₆ inches (c) *Untitled Painting*, 1977, acrylic on wood, 82 ¹¹⁄₁₆ x 82 ¹¹⁄₁₆ inches. Photo: Fred Scruton (d) *Surrogate Paintings*, 1978–80, acrylic on wood and museum board. Installation site: Galerie Yvon Lambert, Paris, 1980. Photo: André Morain (e) *Surrogate Paintings*, 1980–81, acrylic on wood and museum board. Installation site: Chase Manhattan corporate waiting area, New York City, 1981. Photo: Mary Ellen Latella.

still provides a framework of this sort, but there is a shift in emphasis. Pompeii was this wealthy resort town of a civilization now long gone, and the odd things that are left of it are bits and pieces of everyday life, not the fabulous treasures of a power elite. So what you do with the dog is point to ordinary experience, but from this huge, extraordinary distance. You leapfrog over the historical and all that cultural baggage you dislike.

Allan: I think I understand what you're saying. But I need to say, in the first place, I don't necessarily see the *Surrogate Paintings* as nonrepresentational.

Tom: I know you don't. The *Surrogates* could just as easily be considered representational sculpture. I think the question has to do with whether the works represent something or are about representing something. But to me the installations of the *Plaster Surrogates* always seemed to be about taking a position against representation in art—against "pictures." In contrast, the dogs and bones look like they might be pictures in three dimensions.

Allan: That's not exactly the way I think. The motivation behind making the *Surrogate Paintings* was to represent something, to represent the way a painting "sits" in a system of objects. If you look at installation shots, or pictures taken of art galleries—that was the picture I had in mind. I was trying to reproduce that picture of an art gallery in three dimensions, a tableau. So with the *Surrogate Paintings* the goal was to make them function as props so that the gallery itself would become like a picture of a gallery by re-creating an art gallery as a stage set. To me, this was a clear representation of the way paintings looked in the world, irrespective of whether there's a "representation" within the painting or not.

Also there was a theatrical motivation, maybe a Brechtian motivation, in which I wanted the viewer to be self-consciously caught up in the act of wanting to see a picture. So in a sense, the emotional content of these "surrogate paintings" involved the desire to look at a picture. I was trying to trigger that desire by reproducing the entire tableau within which the viewer would be aroused to desire a picture, but at the same time, not fulfilling that desire, so that, again, the viewer would be caught in the act of experiencing this desire. There was something about what that emotion represents that I was trying to isolate. In that sense, the *Surrogate Paintings* were representational to me: they attempted to mirror the mind-set of the person looking at the painting. I don't think it's reaching to call that representational.

In order to make the *Surrogate Paintings* function as representations of paintings, I had to ultimately cast them in plaster so that the frame, the mat, and the picture were seamlessly joined by the same material. They were casts of paintings, so that they became representations of a type of object that is placed on a wall.

Tom: They're most often talked about as "signs" of paintings, but to you, they also represent a more generalized type of cultural object.

Allan: Exactly. But all representations are about choosing to reduce some thing to a "type," to some kind of abstraction. In 1978, when I first made notes to myself about what I thought I was doing, I remember inventing terms like "the standard, occidental wall-mounted artifact." I know that I wasn't simply trying to represent only paintings. I remember thinking that I was just performing mimetically like most artists do. This is the way a gallery looks and feels, and I made an imitation of that. There's not so much difference between doing that and an artist deciding to paint a picture of a nude.

I was influenced by artists like Robert Ryman, Frank Stella, and Daniel Buren: people who seemed to reduce painting to an extremely simple formula—some kind of definition of painting.

Tom: In one way, Ryman could be seen to be making a claim to finishing off the project of painting, reducing it to a simple definition with this very aggressive stance of "that's it—done with."

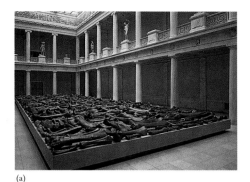 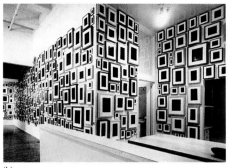

(a) *Lost Objects*, 1991, enamel on cast concrete. Installation site: Carnegie Museum of Art, Pittsburgh, Pennsylvania, 1991. Photo: The Carnegie Museum of Art (b) *Plaster Surrogates*, 1982–84, enamel on Hydrostone. Installation site: Metro Pictures Gallery, New York City, 1985. Photo: Eeva-Inkeri.

(a) (b)

Allan: Yes, but at the time, my perception was that if a painting were reduced far enough, down to its basic *identity* as a painting, the painting would become so self-referential that it would have nowhere to go except to implode and refer back to its position in a system of other kinds of objects that aren't paintings.

That was how I began to want to produce a painting that functioned like a prop. To me this felt like the end result of self-referential painting. The painting winds up only referring to what it is not—which is the rest of the world. The distinction between figurative and nonrepresentational art did not come to mind too often, I don't think.

Tom: To me, the referent is the key to the *Surrogate Paintings* and to the *Perfect Vehicles.* The referent is just the abstract idea—the idealized idea of a painting or a sculpture. In *The Dog from Pompei* and *Lost Objects,* the referents are beings that once lived and breathed.

Allan: That's true. I guess you're right. But filling a rubber mold that's shaped like a painting with plaster is a very similar act to filling a rubber mold that's shaped like a dog [laughs].

Maybe I'm being obtuse here. Of course I favor idealizations and conceptualizations in my work; I guess that's obvious. And if I could have made something that was an abstract representation of time gone by, I would have. But I couldn't think of any real alternatives. So I chose things that already seemed to be representations, already utterly unmediated and anonymous—representations accidentally created by the world itself and not through *artistic* behavior.

Tom: Yet there is a great difference between the generalized ideas embodied in your earlier works and the specific nature of the dogs and the dinosaur bones.

Allan: There was something that appealed to me about the dogs and bones in this area of representation that you're talking about. I felt that in both cases I was working with copies produced by *nature*. I think that part of the challenge we face in living with the copies we make ourselves is that we experience them as alienating because they always seem to represent something else; they're never the thing itself. So to the degree to which we're enmeshed in relationships with our own copies in the world, we are constantly in a state of banishment from the imaginary "source" of things—from the original things that these copies seem to replicate.

This is just the modern condition, you know? This is also inherent in language and in the way we internalize things as representations. We live in a physical world that's filled with copies and representations made from molds, printing processes, templates, dies, and so forth. We live in a world filled with substitutions for things that are absent since every copy, in a certain sense, only exists because the original is gone. So copies are always about something that's absent, and in that way, they carry a sense of mourning, death, or loss. This is one way to look at our environment— maybe a particularly psychoanalytic way.

Tom: Maybe, but there is also the mundane truth that copies are made so that more people can have them at a lower cost than the "original." I think it is too easy to get caught up in the melancholia of reproduction. Life goes on.

Allan: I know. But there is still this very real side effect that we are surrounded not only by the presence of things that we wouldn't have otherwise but also with the

Surrogate Paintings, 1978, acrylic on wood and museum board (a) *No. 8069*, 11 ¹/₁₆ x 9¹/₁₆ inches (b) *No. 80101*, 7¹¹/₁₆ x 5¾ inches (c) *No. 8021*, 10¼ x 8¹⁵/₁₆ inches (d) *No. 8076*, 11³/₁₆ x 8½ inches (e) *No. 8086*, 9¹⁵/₁₆ x 7¹³/₁₆ inches (f) *No. 8064*, 11⅝ x 7¾ inches (g) *No. 7911*, 11 x 9 inches (h) *No. 8019*, 10¼ x 7¹³/₁₆ inches (i) *No.7816*, 6⅜ x 4⁵/₁₆ inches (j) *No. 784*, 8³/₁₆ x 6¹¹/₁₆ inches (k) *No. 802*, 9¹³/₁₆ x 8 inches (l) *No. 8024*, 10⁵/₁₆ x 9¹/₁₆ inches (m) *No. 7914*, 9⅞ x 7¾ inches (n) *No. 8033*, 10⁹/₁₆ x 9¹/₁₆ inches (o) *No. 8108*, 9⁵/₁₆ x 9¹/₁₆ inches (p) *No. 794*, 9½ x 8½ inches (q) *No. 8026*, 10⁵/₁₆ x 9½ inches (r) *No. 8059*, 11⁵/₁₆ x 9¾ inches (s) *No. 80103*, 7⅞ x 6³/₁₆ inches (t) *No. 80103*, 7⅞ x 6³/₁₆ inches.
Photos: Ivan Dalla Tana.

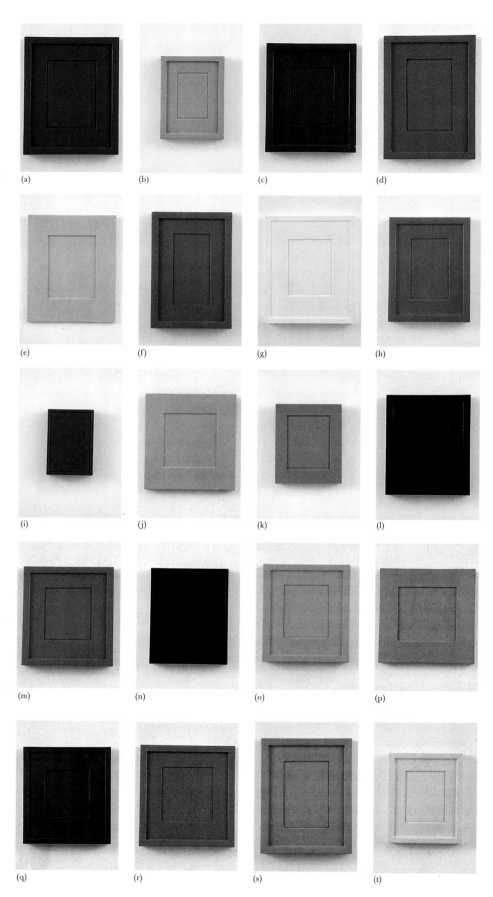

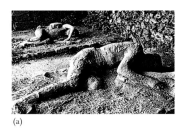
(a)

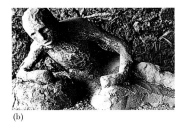
(b)

(a) and (b) Excavations at Pompeii, Italy, plaster casts of victims.

absences that these copies represent. So if I have a certain mass-produced coffee cup, for instance, and I know that thousands of other people have the same cup, that's great, because I feel connected to all these thousands of other people. But at the same time the actual reality of any *particular* coffee cup seems to exist nowhere. So, in a sense, absence is everywhere. So I sometimes experience living in the world as a kind of mourning or as a kind of longing for the things that are always absent. The presence of copies seems to amplify this feeling.

Anyway, I found that *The Dog from Pompei* and the *Lost Objects* could convey this particular way of experiencing representation because they were literally copies of objects that were long gone, never to exist again. The only way you could have a relationship with them at all would be through the duplicates created by nature. I came up with the idea of using fossils because fossils are reproductions almost by definition. Dinosaur fossils, for instance, are created over millions of years during which the bone is dissolved and replaced by silica or minerals of some kind. It's a slow process of development, and, ultimately, what you get is an exact duplicate of the original bone. So I felt that if representation is a sort of alienating mechanism, maybe these objects corrected, or bridged that gap, or naturalized the relationship between the copy and what the copy represents in some uncanny, symbolic way because they are naturally made copies.

Whether or not this distinction makes any rational sense, I think emotionally it makes sense. So one of the meanings a naturally produced copy has for us is that it absolves us of the guilt for living in relation to our own copies all the time. It makes copying a natural thing.

Tom: Are you seeking salvation for the alienation of your old work by using naturally occurring representations?

Allan: Hmm. Maybe! It's about the way we mythologize nature. I'm not offering any criticisms or solutions. I'm mostly describing what I think is a kind of fantasy or wish, and the way these naturally made copies seem to satisfy this wish in some way. I'm not trying to make some distinction between nature and culture here; I'm just saying that as a culture we make these distinctions. We might name a flower after a certain animal because it looks like that animal—we're constantly looking for these correspondences, resemblances. Why is it pleasurable to do that? I think that it's pleasurable because it makes our own copying seem like a natural process, whereas if we didn't find it in nature, we would find our own copying, our own inner representing, to be alienating or troublesomely false. In fact, a lot of "anti-representational" artists from the recent past do view representations as alienating and delusional—encouraging illusions and fantasies and aloofness from reality. Sometimes I agree with these views.

When I first designed the *Surrogates* it was very difficult to convey to people that I considered the frame to be part of the work itself. People would generally look into the window of the mat and think that was what they were supposed to look at. So I think I was considered a monochrome painter by many people. That became a preoccupation of mine—how troublesome it was to convey the idea that the entire framed artwork was meant to be experienced as a whole object in itself.

Tom: It is interesting that people used to think that you were a monochrome painter. In thinking that, they were thinking you were taking a position against representation.

Allan: I think that I had thought these issues through a long, long time before I began the *Surrogate Paintings.* As I said, I had already looked at Frank Stella's paintings, Robert Ryman's and Roy Lichtenstein's paintings, and even On Kawara's paintings, as signs for paintings. And I think there are lots of ways to argue that that's exactly what they are, and perhaps intentionally so. But I don't think other people saw them exactly that way. I saw these paintings as caricatures of paintings, and

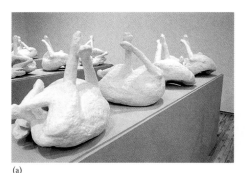

(a) and (b) *The Dog from Pompei,* 1991–92, polymer-modified Hydrocal. Installation site: John Weber Gallery, New York City, 1992. Photo: Eric Baum.

(a) (b)

therefore the work seemed to self-consciously refer to their context in the world at large in ways that other paintings don't. I'd been going through that train of thought for so many years that it took me by surprise that even in 1978 people didn't know how to look at the frame and see it as part of the work. The *Plaster Surrogates* came out of a step-by-step logic from painting in the late sixties. It wasn't as if I one day gave up painting and simply became a sculptor.

Tom: The *Surrogates* are all in portrait form.

Allan: Well, yes, and I made that decision when I decided I also wanted to make a direct reference to domestic objects. A "surrogate painting" was meant to represent a painting in a museum, but at the same time it was meant to represent a photograph of your grandchild, or something like that. It was meant to represent a standard type of cultural object that we make, save, and value—an object in use. Anyway, I think I have to give you a little history of the decisions I made when I decided to do the dogs and bones in order to answer your earlier question.

Tom: Do you think of them as "dogs and bones"?

Allan: I try not to say "dogs" and "bones" together in the same sentence if I can help it [laughs]! When I thought of the idea of using the fossils (and they're both kinds of fossils, really), I was looking for a different type of object that functions as a kind of valued thing to the culture. Just as the *Plaster Surrogates* could represent the Mona Lisa or a graduation photo, I was trying to collapse two other kinds of disparate objects into one sign. I was also trying to come up with some sort of project which could represent a connection with the past, or our desire to be connected to the past.

If you look at my work from around 1975 to now, I think you can separate the work into categories of objects. And usually these categories can be defined by some attempt on my part to do a type of object which already exists in the culture, something which is collected and saved and satisfies or appeals to certain emotional needs or desires. I was thinking, What do we have in our homes? What do we have in museums? Well, you have certain types of objects which we value because they seem to be more than what they are.

Religious objects would fall into this category, and fine art objects, of course. So with the fossils, I was thinking of a category of object that we save to remind us that the past exists, both on a cultural level and on a personal level. It's funny, because you can make a sign for a painting and duplicate it, but you can't make a sign for an old object and duplicate that aura that comes from age. You can't synthesize or invent that; you can pretend. You can buy copies of Nefertiti or something, but you will always know it's a copy even if it's made from a mold made from the original. It doesn't give you what you would want from a really ancient object.

Tom: I wonder. I recently got a phone call at school [California Institute of the Arts] from a woman who said she had some Egyptian artifacts that her husband had collected and loved. She wanted to get rid of them because he had died recently. I went to visit her and what she had, in fact, were a number of souvenirs her husband had bought at the King Tut exhibit when it was at the Coliseum in Los Angeles: a couple of bookends, a little cast of Nefertiti. They were objects with no value as artifacts, and they were of no value to her because she hadn't shared his interest in Egyptian souvenirs. But they did refer to some desire of her husband.

Allan: But they did have value to her because they had value to her husband. So much value that she wanted to do something significant with them rather than just throw them out.

Tom: Exactly. She wanted art students to use them for drawing exercises, a step above throwing them out. There was a reluctance to toss them completely, which was her real impulse. We were talking about the satisfaction with the copy—I think her husband was completely satisfied with them.

Allan: I don't know.

Tom: The one original item he had in the collection was a little pyramid filled with sand that his friend made for him with sand from Egypt. This man's only encounter with Egypt was through the exhibition. But his friend managed to go to Egypt and brought him some sand and made this little, tiny pyramid.

Allan: My grandmother's grandfather was a ventriloquist and performed around the country in the late 1800s. My grandmother lived in southeast Texas when she was a little girl, and he once brought a little present of seashells from San Francisco. She saved them, and just before she died, she divided them up, got a kit from the craft store for making little plastic paperweights, and made one for each grandchild so that each of us could have a little souvenir from her grandfather: seashells encased in polyester resin. I still have mine.

Tom: You have so many stories from your family's history that prefigure your current interests.

Allan: What you were describing reminds me of another story: My grandmother died in 1977, around the time I first started the *Surrogate Paintings,* and I was trying to determine the final form they would take. When she died, she left behind things that nobody knew about; they were essentially souvenirs of events that had nothing to do with anyone still around. It's an extremely strange feeling to have an object that meant something to somebody who's gone. You don't know what it meant, but because it had meant something to someone you loved, it now means something to you. It's hard to say how much the objects mean, because they only seem to *almost* mean something. But they mean enough to you that you save some of them. I remember feeling that it was this kind of imminent meaningfulness that I wanted the *Surrogate Paintings* to have. I wanted them to refer to things that we value without necessarily knowing all the reasons why.

Tom: Like old family photographs that you find, and you don't know who any of the people are, except you know that one of them might have been your great-grandparent or something?

Allan: Yes, exactly. And that doesn't only happen with heirlooms. I'm forty-eight now, and I have objects I've kept whose significance has been lost to me. I know they meant something to me once—related to some friend or some event, but I honestly don't remember. I'm afraid if I throw them away, I'll lose these meanings forever, but, then again, I'll probably never remember what they were anyway. But these objects have an aura of meaningfulness that's unknowable and nonspecific.

Tom: So that's what's crucial with the *Perfect Vehicles?*

Allan: Well, with the *Surrogates,* yes. But I guess with the *Perfect Vehicles* the aura of imminent meaningfulness became more and more amplified and more refined.

Tom: Because you made them look somewhat more like family heirlooms in some abstract way?

Allan: No, not exactly. I wanted the *Surrogates* to represent both an object that the culture at large values and an object that an individual might value within his or her own lifetime. For the *Perfect Vehicles* I chose the vase as an object that seemed to have that same spread of potential meanings. If you go to the Victoria and Albert or the Metropolitan Museum, you can see vases that have similar shapes to the vases

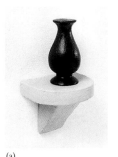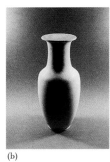

(a) (b)

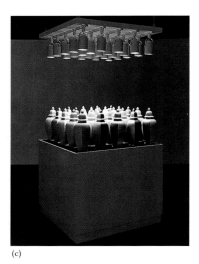

(c)

(a) *Diptych* (study for *Perfect Vehicles*), 1980, mixed media 9½
x 4⅜ x 4⅜ inches. Photo: Fred Scruton (b) *Maquette for a
Sign* (study for *Perfect Vehicles*), 1983–84, solid-cast Hydrocal,
height 15 inches (c) *Twenty-five Perfect Vehicles with Twenty-five
Gallery Lamps,* 1986–87, acrylic on solid-cast Hydrocal.
Installation site: Diane Brown Gallery, New York City, 1987.

you can buy at Woolworth's. So, since I intended to make a reductive sculpture, all I
thought about were the shapes. I tried to find one that could function at either end
of the continuum of meaning, of value, and of enhancement.

Tom: Why are they grouped—is it in fives?—together?

Allan: I group them in all kinds of different ways. This is very hard to explain
exactly. I think there's something very poignant about the mentality of modern man.

Tom: Man as in mankind, or male?

Allan: No, I mean modern human individuals. This is a very American thing:
the individual's desire to seek out "needs," to define them, simplify them, and try to
satisfy them. You see this especially in the production of consumer goods and in
modern science as well as in the arts. I think it's a modern desire. I don't exactly
know why that's the case, but it's an interesting area to explore. So sometimes when
I'm functioning as an artist, I'm functioning as an individual in terms of my own
feelings and wishes and so forth. At other times I try to inhabit that part of me that
is a modern person who has this impulse. So there is sometimes that self-conscious
conceit going on with me.

When I made the *Perfect Vehicles,* I was purposely functioning in a voice that
naively (maybe) and optimistically felt that a religious object could be reduced to
some kind of simple thing that one could then reproduce, that would represent all
transcendent feelings at once. It's a preposterous goal, but it's the kind of thinking
that people who design national symbols must go through. In order to amplify
that posture, I decided that if this modern person wanted to create a highly
overdetermined symbol, it would be much better to make a lot of them, speaking
as this modern person who would think like this—and modern people do think
like this. So I had this idea that you could create something like a power station—
that was the reason to put a number of *Perfect Vehicles* together. The aura of value
and significance would increase exponentially with the number of objects you
put together.

But the vehicles are more than "religious" objects—they are also represen-
tations of "fine art" objects. There was something else I intended to do with the
Perfect Vehicles, which was to depict that particular dramatic process of an object
made to convey some charged meaning that is required of it by culture. As a kid
growing up in Los Angeles, I remember that "perfect vehicle" was a common
phrase—a film director or an actor was always searching for the perfect vehicle that
would draw on his own particular, unique talent. So this idea that one could come
up with a "vehicle" that was perfectly suited to expressing who you were seemed to
me to be a principal "mythic quest" of the artist or poet. Everyone's looking for that
"perfect" form, and the viewer is also looking for the art vehicle that somehow cap-
tures and expresses his or her own feelings. Through identification, the viewer finds
his own inner truths objectified. So I was interested in the mythology and how it is
mediated through objects that artists make. In a sense it's essentially what artists
do for a living, and it's also the critical basis for judging the success or failure of an
artwork. Everyone's looking for this means of conveyance, and the art object occu-
pies the center of this search. Maybe this quest had religious significance before it
became artistic: an object might have symbolic significance that far outweighs its
day-to-day usefulness.

Tom: This all sounds very Walter Benjamin/Frankfurt School, which is not as
interesting as your take on the Hollywood idea of the "perfect vehicle." I'd like to
hear more on the film actor's search for acceptance and the mass circulation of
religious objects.

Allan: The fact that they exist in such immense quantities reinvents a whole
new kind of aura—is that what you mean? I guess that's why I brought up the
example of a religious object in the first place, because I wasn't talking about an

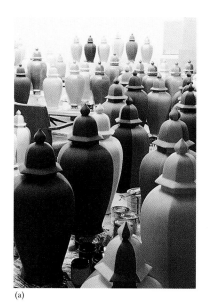

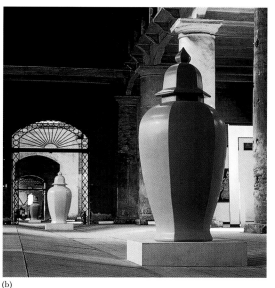

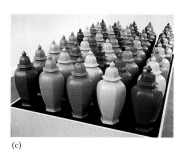

(c)

(a) *Perfect Vehicles*, studio view, 1986 (b) *Perfect Vehicles*, 1988–89, Moor Glo on concrete. Installation site: *Aperto 88*, Venice Biennale, 1989. Photo: Courtesy of Brooke Alexander Gallery (c) *Fifty Perfect Vehicles*, 1985–89, enamel on solid-cast Hydrocal. Installation site: Stedeljik van Abbemuseum, Eindhoven, Holland, 1989.

object that's enshrined, that's a one-of-a-kind, piece-of-the-cross type of object. I was thinking about the plaster Madonna that no matter how many times it's reproduced, how many homes it exists in, it still has significance and meaning and aura to the person who believes.

Tom: Doesn't the plaster Madonna represent aura, the Church, and religion, et cetera? Do the *Vehicles* represent the "aura of art"?

Allan: To me they do. Maybe that sounds too simple. I was trying to come up with an object that represented all of those mechanisms of looking at a thing and being caught up in some transcendent feeling that wasn't in the thing itself, but the thing itself acted as a catalyst for these other feelings and, in that sense, functioned like a vehicle. And I think I was trying to represent this kind of object as part of my work. But like you said, by doing them in quantity I was also contradicting the idea of the unique, singular . . .

Tom: Is it the quantity that creates the idea of absurdity?

Allan: Or intensity.

Tom: There's a funny intensity.

Allan: Faced with large quantities of the same object, maybe you come to realize that what you're feeling couldn't be real because it's absurd to think that the "Holy Spirit" is more present in ten thousand plaster Madonnas than in one. But in fact, if you saw ten thousand Madonnas and you believed, you probably would feel that. There's that discrepancy about what makes sense and what doesn't make sense, especially in the context of religious feeling. So even a deeply religious person in the presence of ten thousand Madonnas might consider it to be slightly absurd. But at the same time they might realize that the power of belief exists within themselves and not in the bits of plaster. I'm not sure.

Tom: But laughter is one response to your work.

Allan: I understand what you're saying. There have been times when you go into somebody's home—a mother of a friend or something— and see the objects that they find so valuable, like this pyramid you were talking about, or the pencil that says, "I like Pussy"—was that your story?

Tom: That was Richard Baim's story [laughs]. They didn't know the American slang. He saw this pencil at an Italian friend's parents' home in Tuscany. They had many pet cats and cat knick-knacks, including this pencil their son had innocently (or not so innocently) brought back from America.

Allan: You go into somebody's home and you see something funny in the objects that they value, and it makes you uneasy. Let me say that I don't think the *Perfect Vehicles* are as funny as other people do. I do understand that they're funny,

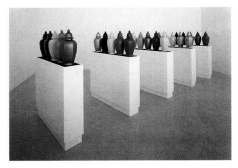

Perfect Vehicles, 1986–87, enamel on solid-cast Hydrocal.
Installation site: Galerie Yvon Lambert, Paris, 1987.

but I don't think they're as funny or ironic as other people seem to think they are. And while I don't necessarily look at them and have what you'd call a religious experience, I do look at them and think that I might, maybe, if you know what I mean. I don't make them with the kind of irony that people seem to project onto them because I'm actually very suggestible. If I see an object that someone else values to the extreme, I'm moved by that. As I said before, I would have a hard time throwing something away that someone else valued, even though I didn't understand why it was valued. So I suppose the *Perfect Vehicles* can appear as comedic to some, and I recognize that they do. But this always hurts me a little bit. To an outsider the over-valued object seems silly and is made even sillier by the owner's emotional investment in it. But I want my work to amplify the poignancy of the estrangement from belief that we suffer in the face of the unfamiliar values of others.

Tom: No, I think that's where the poignancy is: they're absurd and funny, but you know that they also refer to an idea of value.

Allan: Maybe what you think of as "funny" I tend to think of as "poignant." I must feel that the poignancy increases as the sense of the comedic increases.

Tom: I can't bear to watch situation comedies because you can always see the jokes coming. At a certain point I can't take it any longer. Is that poignant?

Allan: Well, look at the tragedy of being an alcoholic and the number of jokes ridiculing alcoholics. It's funny and it's not funny because it's tragic, and maybe there's a difference between the way you and I look at things, too—you favor the comedic over the poignant. There's something tragic and poignant, it seems to me, about looking to an object to have meaning when obviously the object is just functioning as a symbol. There's something sad about that because it means that what you want you don't have; all you have is the substitute, and that can be seen as basically sad.

I once read a book by a famous clairvoyant who claimed that he could see people walking around who had died but couldn't leave the "earth-plane." And the reason they couldn't was that they were addicted to something. He said he once saw the spirit of an alcoholic curled up in a barrel of wine. And he claimed that people addicted to nicotine have a hard time leaving this earth-plane because they're constantly looking for cigarettes, and re-creating what he called "dream cigars." So that would be horrible if it were true, but it's also funny.

Tom: That's ridiculous.

Allan: Well, if a man puts flowers on his wife's grave, would that strike you as funny?

Tom: No. Grieving for a lost love or honoring a memory—these are genuine human acts. But claiming you can see lost souls in empty wine glasses and dirty ashtrays is just nonsense.

Allan: These are all similar kinds of concepts to me. I think that each series that I do tends to explore a different kind of valuation or kind of meaning or significance that we look for, that we value in an object. We tend to separate our valuations into categories, but they all blend into one another. The *Perfect Vehicles* are similar in many ways to the *Plaster Surrogates*—sort of a three-dimensional version of them. On the other hand, the *Perfect Vehicles* have that reference to transcendence that is much more obvious, as you pointed out. That aspect overlaps into my other projects. They all form a project as a whole, I suppose, which in the end might form a certain picture of my emotional life. I suffer estrangement from tradition, and that sometimes makes me really unhappy. I hope I'm depicting some kind of more universal condition, especially with regard to the objects we value. I tried to make the *Perfect Vehicles* look like they were made with a great deal of care, which they were. They take a long time to make in the studio.

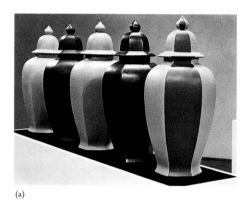

(a)

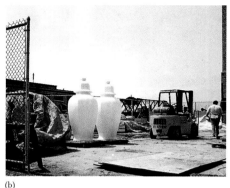

(b)

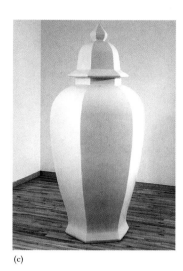

(c)

(a) *Five Perfect Vehicles*, 1985–86, enamel and acrylic on
solid-cast Hydrocal. Installation site: Rhona Hoffman Gallery,
Chicago, 1986 (b) *Perfect Vehicles* (in progress), 1988, cast
glass-fiber-reinforced concrete. Photo: Ivan Dalla Tana;
(c) *Perfect Vehicle*, 1988, MoorGlo on glass-fiber-reinforced
concrete, 78 x 36 inches. Photo: Fred Scruton, courtesy of
John Weber Gallery.

Tom: Why is that?

Allan: Well, you think that it's easy to make something look perfect, but it isn't
[laughs]. We use rubber molds and make the objects out of plaster, and it takes hours
and hours of sanding and shaping. Even though the mold is as perfect as we can
make it, every mold warps. And then there are coats and coats of paint.

Tom: Are they usually one color?

Allan: They usually are.

Tom: Sometimes they have stripes, don't they? That must make them more
difficult—to get the stripes perfect?

Allan: You're not being sarcastic, are you [laughs]?

Tom: Me [laughs]? Do you still call them *Perfect Vehicles* when they're large?

Allan: Yes, they're just the same; only bigger!

Tom: But they're not just the same, they are bigger. I remember being at your
opening when you first showed them and standing around talking. As I moved my
head in conversation I glimpsed one out of the corner of my eye, and for that moment
thought there was someone standing beside me. It was a little startling.

Allan: Of course they're going to have a different kind of presence. In
designing the *Perfect Vehicles* I was trying to make some objects that were highly
overdetermined and that were maybe even inexhaustible in their potential as
symbols. I chose a particular kind of vase to copy that had a lot of masculine
characteristics as well as feminine, and that had certain references to machines as
well as to the organic. I tried to elaborate upon the typical kinds of things people say
about vases representing femaleness: wombs, breasts, and at the same time giving
them an almost military, phallic presence. Anyway, I was aware that they also had an
ambiguous anthropomorphic presence which just didn't work as dramatically on a
small scale.

Tom: So the big ones are more perfect?

Allan: Yes! And also because they don't reference the mass-produced object so
readily. At the moment when I started showing the *Perfect Vehicles*—because of what
some popular, younger artists were doing at the time—I didn't quite anticipate that
that reference to mass consumption was going to be favored so strongly in people's
perceptions of the work, especially by younger art critics. They were being perceived
in a way that I thought was out of balance. The large ones sort of solved that dilemma,
I think. The larger ones are necessarily more singular. And also a lot heavier.

Tom: They're different materials?

Allan: They are, but that's a technical thing.

Tom: You think? The big ones are concrete, aren't they? Doesn't concrete have
a different connotation from plaster? You don't have a material content? One of the
funny things about them is, either way, they're closed off. But critics have tended to
make an issue of the fact that the small ones are solid and the big ones are hollow.
Which is obviously…

Allan: Of course they also have material content. Concrete has a different
connotation from plaster. I chose plaster for the smaller ones because it runs the

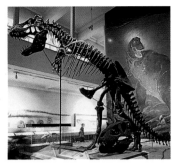

Tyrannosaurus rex, Saurischia order, Late Cretaceous, length 47 feet, height 18 feet; from Hell Creek, Montana. © The Board of Trustees, Carnegie Institute, 1990, Pittsburgh. Photo: V. Abromitis.

cultural gamut from its common use in simple children's crafts to its sophisticated use in commercial reproductions and artists' studios. Gypsum has been in use for thousands of years, so to me it has a feeling of being a very primary material.

If I felt I could have made the larger *Perfect Vehicles* solid, I would have. It's just that you'd need a crane every time you moved them. That was an important point, that they be solid; I was looking for an object that would grow in meaning and value through projection. That meaning would be projected onto it, or into it. I felt that if they were hollow, that hollowness would be confused with whatever meaning we might feel was inherent in the vehicle itself. In other words, if you can't physically put anything in it, then you're only going to put meaning into it—you can't put flowers in it, or ashes. Even though the large ones are hollow, the lids are part of the form as a whole, and they don't come off!

Tom: I had a teacher in primary school who would tell off noisy kids with the phrase "Empty vessels make the most noise" [laughs].

Allan: I've heard that expression. But "empty vessels" is different from *Perfect Vehicles* [laughs]. This reminds me of an article I read in a magazine about a wealthy nineteenth-century American who was constantly going back and forth by ship between England and Boston, and he owned these two oriental vases, each about six feet tall. He loved them so much that when he traveled back and forth he took the vases with him. This image of somebody carting around these cumbersome exteriorizations of some quality of great inner significance is an image that reoccurs in my thinking about most of the objects I make. I always picture people carrying my objects around before I make them, especially the bones. To carry around a dinosaur bone would be particularly poignant and cumbersome.

To me the dinosaur bones, being so huge, seemed like the perfect metaphor for the way that a copy embodies an absence because dinosaur bones only come to us as copies in the first place. They represent this enormous, monumentally sad absence of a whole world we'll never retrieve again. To me, making copies from a mold feels like constantly trying to bring something back that used to be there but isn't anymore. You take a cavity that's made of rubber and you fill it with plaster and you pop it out and it looks just like the original, but it isn't quite. So you do it again and again and again.

With the fossils, I was trying to further extend this picture of the dramatic role objects play in emotional life. What I felt was missing from the picture was a kind of connectedness to history—to time, to the past. So, as I've said before, I was looking for an object that would really do that and not simply be a copy of something else that did that, or an arbitrary sign of something that did that. But there are very few kinds of objects that I could possibly imagine that might give you that sense, while at the same time being infinitely reproducible. Instead of focusing on historical relics or heirlooms or certain types of things that we could easily find, I found myself having to choose something that was quite atypical. My feeling was, since the fossil was already a duplicate, there wouldn't be any loss of authenticity by reduplicating it; I would simply be extending a series which was already begun, in a way.

Even more to the point, the Pompeii relic was a *cavity*, not a solid thing. The dog was killed in A.D. 79; it was smothered and then it deteriorated within its own cavity. But the cavity itself wasn't discovered until 1874, and it was only at that point that it was filled with plaster. The Vesuvius Museum made the mold for me in 1991. It's an object that's difficult to date. I was tempted to date it A.D. 79 because that's when the original cavity was made. So it's a problematic object in that it's a copy—a copy of an object that only existed as a copy to begin with, without having had a "real" existence during any prior point in history.

Tom: Or existed as this empty space that once was a dog—it's a representation of a moment in time.

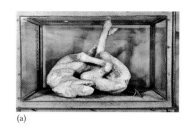
(a)

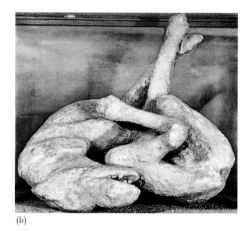
(b)

(a) and (b) Postcard of excavations at Pompeii, Italy, plaster cast of dog.

Allan: In the title of the piece, *The Dog from Pompei,* I chose to give Pompei the present-day spelling, because that's where I obtained the cast dog, in present-day Pompei. But it was Pompeii—double *i*—at that moment in time when the dog died. Copy editors are always changing my title back to the ancient spelling because they think that it's more correct. So everyone seems to be confused about how to date it.

I determined that I wanted to make an object that offered a connectedness to the deep past. I also determined that it had to be something that wasn't connected to any specific culture. Usually, if we go to a history museum, we don't see things like the Pompeiian dog; for example, we see things that belonged to a particular king or era or battle, and you know they're artifacts or relics that have to do with some individual or culture. Obviously the dog did come from Pompeii and refers to a specific geological event. In the end it's only a dog: it's not made of gold, it's not carved, it doesn't reflect any style or any culture. At least that's the way it seemed to me. I was originally looking for the famous loaves of bread when I went to Pompeii. It turned out that those loaves of bread are real.

Tom: The bread is preserved?

Allan: Yes, and I was so disappointed because I remembered as a child reading that the Pompeiian loaves of bread were cast in plaster—but I remembered wrong. So that narrowed down the choices.

There was a chest with doors and hinges which they had cast. They had found a three-dimensional rectangular cavity, and they plastered the sides with concrete and excavated it and it turned out to be a chest with molding and everything. They wouldn't let me do it. It looked very much more like an art object of a more abstract type. It would have had a whole different slew of references.

Tom: What kind of issues did the curators and conservators at Pompei raise?

Allan: I was very lucky because they didn't get all that involved in the end, but early on there were issues. There were certain things that had been very well documented and other things that had not been documented. The chests were discovered more recently, and that seemed to be a big issue.

Tom: It was infringing on their potential commerce, in a way.

Allan: My dealer in Naples and I wound up getting the dog from a museum that was a little to the side of the site called the Vesuvius Museum. And what they had was a secondary cast of the dog, as there had only been two or three copies made. And the reason that they were able to get their copy had to do with somebody who was related to somebody the museum people knew who had worked on the site and was allowed to make a copy for them. It wasn't the actual first cast dog that came out of the ground. I kind of wish it had been, but ultimately it doesn't really matter because since then I've made three additional molds. It doesn't matter because they all have the same relationship to the original cavity. A young man who was working on the site at Herculaneum, who was an archaeology student and friends with the site's restorer, knew the director of the Vesuvius Museum and they let us do it. So I didn't have to go through Rome; I only had to go through Pompei. That made it much easier. We applied to Rome for permission to use the other objects, and they refused us.

I ultimately chose the dog. At first I was afraid of the drama of the thing, it seemed so incredibly overdramatic, dramatic beyond any necessity. But in the end I think I chose it because it is so poignant, so evocative. I mean, people have actually cried when they've seen it—when they see my copy of it. When I had the show in Madrid, somebody cried. It has nothing to do with what a wonderful artist I am.

Tom: Oh, I don't know. You shouldn't downplay your role. It is the way that you draw attention to the object that makes it seem so moving.

Allan: Whenever I see it, my initial feeling is to feel sorry for the dog—to feel empathy for the dog. But how empathetic can you really feel for a dog that died

nineteen hundred years ago? It's almost a preposterous emotion. I think, in a really interesting way, it introduces a feeling about time that is very familiar and intimate. How can I say this? It seems to me if we didn't have artifacts to remind us about the past, everything would disappear. We would be living in the continual present all the time. The only way we have any sense of the past is through artifacts, or memories— if memories can be called artifacts. We either have inner representations or outer representations, but we don't have any actual experience of the past. We can have wonderful representations of the past, voluptuous and emotionally charged representations of the past, but they're always going to be just representations and stories. I came to feel that the dog seemed to exemplify this drama and was a dramatic object that embodied that feeling of estrangement from the past even as it invoked the past.

Tom: Does the dog encourage a narrative? Or does the repetition of the dog prevent that from happening? Last time we talked, you said something about the dinosaurs—that the fact of their existence is so strangely threatening because they represent an environment that would have been hostile to humans. And in a way, the dog does the same thing because it is a record of a moment when the earth was hostile to humanity.

Allan: When I originally wanted to use the loaf of bread, I wanted to use an object that had utterly no significance, that was mundane, that was domestic and ephemeral, that was only accidentally preserved, and that was unsettling exactly because it was so common. Because to look at the ghost of a common, everyday object that's nineteen hundred years old is unsettling or is provocative, not because it belonged to anyone in particular, but simply because it's still here, and we recognize it.

Here's an example: When I was a truck driver in the sixties, I worked for an art-handling company in Los Angeles, and I once delivered something to a collector in San Francisco. He tipped me: he put a trilobite fossil in my hand, and I said, "What is this?" And he said, "It's a trilobite. This is 300 million years old." I looked at it and thought, My God, holy cow! But on the way out the door, I thought, Yes, but any rock I pick up might be 300 million years old! So I don't know how to explain it very well, but I wonder why is it that we don't perceive every rock that way? It isn't uncommon to find a 300-million-year-old rock—they're probably in your garden—and why doesn't that amaze us as much as an imprint of the trilobite amazes us? It amazes us because there's more of a story there, more of a drama.

Tom: There's the evidence of life.

Allan: And death—that's a story. To a geologist any stone is a story, but not to most of us. So I'm interested in how that is suppressed, how we walk around not only not thinking about death but not thinking about time, not thinking about how much time has passed on this planet. To me this daily amnesia is a good symbol of unconscious repression in general. It's something that is so obvious to all of us and we all know it, especially if the object is a bone, because it's obviously an allegorical thing too, a reminder of death. The planet's been here—I don't know how long it's been, billions of years—and life has been around nearly that long, and we don't dwell on the significance of this on a daily basis. The awareness of time falls into that category of other things that we push out of our consciousnesses, like sexuality, violence, death, and so forth. And we save objects which seem to me to allow us to dwell on this only when we feel like it. Or we create archives that we visit to look at these things on special occasions. I'm personally surprised that everybody doesn't collect fossils. Why wouldn't everyone want three or four fossils? They have a significance that goes beyond any artwork. Yet people are generally more apt to have artworks than fossils.

Tom: I know I keep trying to beat this dead horse, but I'm just trying to get something clear. You have this great interest and respect for fossils, for example,

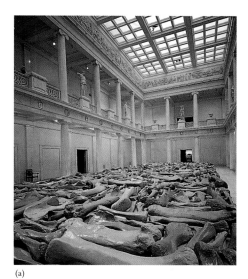

(a)

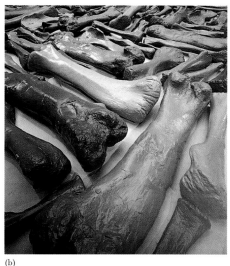

(b)

(c)

(a) and (b) *Lost Objects,* 1991, enamel on cast concrete. Installation site: Carnegie International, 1991, Carnegie Museum of Art, Pittsburgh. (c) Juvenile *Stegosaurus* fossil bones under excavation at Dinosaur National Monument, Utah.

because they work as souvenirs of long ago—it makes you think of the fragility of life. It seems to me that before you started working on the fossils, your work was generated out of your disappointment with cultural artifacts. They represented a cultural memory that was an alien one to you—it was the memory of a power elite rather than the memory of the ordinary person. So by leapfrogging over history, so to speak, you have found a way of getting at the issue of time and memory that avoids the issue of culture.

Allan: Yes, you're right. I see what you mean better now. It was a conscious choice, similar to the way that I avoided making "pictures" when I did the *Plaster Surrogates.* When I decided to do the *Surrogates,* I had two ways to go: I could have done either every image or no image. I opted for no image. I guess in the same sense I wanted to produce an object that carries with it that deeper scope of time—the scope of time which obliterates or relativizes history. It would have seemed overly limiting to choose a particular historical period. Pompeii, of course, existed during a certain period. So you can't say that the plaster dog works perfectly on that level, but you can say that it's very problematic to date the thing. But the dinosaur fossils do leapfrog over the problem, like you say, and I was surprised to find how satisfied I was to produce the *Lost Objects.* They satisfied a lot of my visual needs in terms of their forms as well as my intellectual interests in what they were capable of signifying. And they're so monumentally sad.

Sometimes I almost self-consciously functioned as an American when I was plotting out the dinosaur project. I went out to Utah to see Dinosaur National Monument, where a lot of those fossils were found that I borrowed from the Carnegie Museum of Natural History to make my molds. I enjoyed the discovery that people in Utah, especially the people that I talked to who work in museums there, claim dinosaur bones as their heritage. It might seem peculiar to you as a European, but responding to that as an American, I totally understood what they meant. I think that from a European perspective one might think, It's not your heritage; if anything, it's the earth's heritage. So I think what you're perceiving is true, that there is an element in my work of wanting to neutralize all of the complicated factors when it comes to cumulative culture. There are so many other ways that beautiful objects can come into existence! I think this is very American of me.

In a sense, culture is too much to have to think about. It's too much to have to know. This is probably not only an American impulse; it's probably more generally a modern impulse to want to reduce things into some simpler form. I'm not trying to tell you that I think this is just an observation of yours, because I do think it's there in the work, but I just want to contextualize it. I didn't think that you could get at that

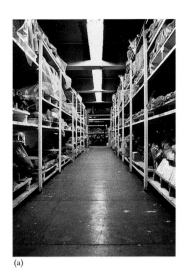

(a)

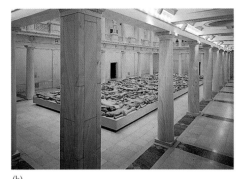

(b)

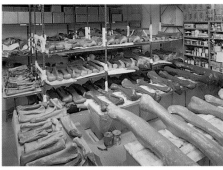

(c)

(a) Carnegie Museum of Natural History, vertebrate paleontology bone storage, Pittsburgh. Photo: Jack Schecter (b) *Lost Objects*, 1991, enamel on cast concrete. Installation site: Carnegie International, 1991, Carnegie Museum of Art, Pennsylvania. Photo: Eric Baum (c) *Lost Objects* (in progress), 1991, enamel on cast concrete. Photo: Fred Scruton.

feeling of "timeness" without leapfrogging over cultural artifacts. What was I going to choose—something Sumerian? or Mayan? It would always be something from somewhere. Then it would be, why choose that and not the other? So I narrowed it down to a very rare, almost curiosity type of object more than a historical type of object. And really, now I can't think of any other object that satisfies those criteria that I have just described and that comes to us as a copy but still has that direct, indexical relationship to the past—can you? Fossils are the ideal thing since they are by definition traces or imprints.

Tom: I didn't see the Carnegie installation. I just saw a photograph which was shot from the balcony looking down. In thinking about the piece, had you been thinking about the exhibition's context and how your work would look with European art? It's quite striking. You could start to make all sorts of associations about these limbless, classical sculptures looking down on broken bones.

Allan: I think I liked the room mainly because it was big and very grand, and maybe it would lend a little drama to the piece. I don't know. More significantly, if you walked through the door in back, you walked right into the Natural History Museum. It was the only gallery that connected to it. I didn't mind the classical sculpture surrounding the room, but I didn't mean to make too big of a drama between nature and culture. It was as much happenstance as anything else.

One of the things that I think is unique about my work, and it's a big problem that I have, is that it doesn't have any site, really. I mean, the *Plaster Surrogates* and the *Perpetual Photos* have to go on a wall—that's about it. I design the objects before I really know what I'm going to do with them—that's the case with the bones. I'd been wanting to do cast dinosaur fossils for years, but I had no access to any. I happened to be invited to be in the show at the Carnegie Institute, so I was finally able to get access to fossilized bones. As I said before, I pictured people carrying them around, but I didn't really know what I was going to do with them. It was the same with the *Individual Works*: I didn't know what I was going to do with them, and I still have a problem with not knowing what to do with them.

Tom: That's connected to the whole idea of identifying a need, fulfilling it, simplifying it, and culling it, because it is all done in a vacuum.

Allan: Yes, I guess so. It's appropriate that I find myself in this dilemma, and it's appropriate that I find myself with so many objects that I don't know what to do with.

Tom: Storage is so predominant in your studio. Your studio is itself becoming a kind of museum archive. With your method of production, you're always in production, aren't you?

Allan: I tend to keep producing. I usually keep going on with a project until it completely bores me to death. I'm interested in the quality an object has when you know there will likely be more of them. But any one of my artworks may be made up of hundreds of smaller artworks. I produce works in collections, so if I'm doing an exhibition, I may have a single collection on exhibit, but there may be hundreds of objects in that single collection to look at. So I have to produce them one at a time.

Tom: "Collections" sounds like a marketing device of some sort—the fashion industry presents new collections.

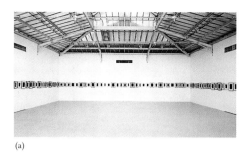

(a)

(b)

Allan: Doesn't it also sound like the Museum of Modern Art, or any museum or patron? It's not my fault that the fashion industry imitates the language of the cultural elite [laughs].

Tom: What's behind the idea of a collection?

Allan: People collect objects. Having just one of them doesn't convey that fact, so that's why I like to make lots of objects. It's contradictory in a business sense because it makes my life really complicated, and my art dealers don't like it.

I just did a drawing show at a gallery in London last year, and since they had all the framing done over there, I naturally expected them to attach labels to the backs of all 2,070 drawings the way galleries generally do. Well, they labeled a hundred or so, but then they got bored and frustrated and stopped doing them. I was kind of irritated by that, but they were thinking that I've got to be nuts, expecting them to label 2,070 drawings. So I had my assistant sent to London to help them. It's paradoxical that I produce objects that have to be individually registered and individually signed and considered, but the artwork itself, as a whole, becomes a collection of maybe 400 or so of these individually considered objects.

Tom: Even in a hypothetically limitless market, you will have a storage problem.

Allan: I'm that kind of person. I tend to want to fill a space when I see it. If I have an extra corner in my studio, I say to myself, I can store such and such there, so I make some more. Working in extremely large quantities is inherent to my thinking because in trying to construct this picture of art objects and emotions in interaction, I want to take into account not only the relationships that the art objects have to one another but also the relationships they have to all the other kinds of objects in the world that are not art objects. It seems to me that one of the determining features of an art object is that it's a unique object almost by definition. I don't think that the meaning of the uniqueness can really be understood without recognizing it in relation to objects that are not unique, that are largely mass-produced objects. When I began to think most about this particular issue—about uniqueness as a quality which is only defined by its opposite—I guess I got involved in mass production in a minor way.

Tom: With the *Surrogates*?

Allan: With the *Surrogates,* yes. I originally began using mass production in the late sixties as a kind of dramatic device. But then I began to realize that this was an interesting dilemma in the way that I just described it. I don't know how to say it. It's that our conception of what artworks are, and should be, and how we expect them to function. We expect them to be rare, and we expect them to be emotional, passionate, and we expect them to be spiritual (maybe) and spontaneous. We expect art objects to symbolize what it means to be human—to have qualities that a machine cannot reproduce.

I began to recognize that the issue isn't simply how we define what an art object is but how we define what it means to be human. And for whatever reason, when we say something is human, we are usually referring to all the qualities that are not mechanical. So how are we to understand what it means to be human if we don't also understand what we consider to be nonhuman and mechanical? In a similar way, art objects are expected to be about passion, spirituality, expressivity, spontaneity, and the recording of special, magic moments, and so forth—the kinds of things we find in a typical expressionist painting. How can we understand what that means if we don't realize that the artists who produce these artworks exist in a culture that is saturated with copies and mass-produced objects that are often all essentially the same? In a world where everything is "unique," the concept of "uniqueness" would have no significance.

(a) *Plaster Surrogates*, 1982–90, enamel on Hydrostone. Installation site: Galerie Yvon Lambert, Paris, 1990. Photo: K. Ignatiadis (b) *Plaster Surrogates* (in progress), 1985, enamel on cast Hydrostone. Photo: Allan McCollum.

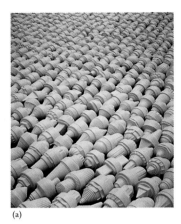

(a)

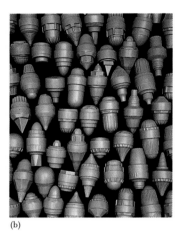

(b)

(a) *Over Ten Thousand Individual Works*, 1987–89, enamel on Hydrocal. Installation site: Stedeljik van Abbemuseum, Eindhoven, Holland, 1989 (b) *Over Ten Thousand Individual Works*, 1987–88, enamel on cast Hydrocal. Installation site: John Weber Gallery, New York City, 1988.

To me, this contrast became more interesting than either the works of art themselves or the mass-produced objects. This is what I became interested in at the end of the seventies. I grew interested in how that dichotomy itself describes a picture of who we are at this historical moment. Then I began to consider that there was a kind of group denial of what mass production was expressing. If it was a general expression of who we were, then it must be expressive of something. We think we know what we're expressing with works of art—and you've written about this particular aspect of expressionism—how interesting it is that all this expressionism looks alike, and so on. It's peculiar that we burden the artist with all this expectation of being expressive and relieve industry of this same expectation. I feel that if you look for human values only in artworks and pretend that human values are not relevant in industry, then you're creating a situation where people feel no moral responsibility for what's being mass produced.

And so I felt compelled to think about these things and explore these issues to try to produce an artwork that also depicted what I felt industry expresses, and produce a kind of object that was at the same time a mass-produced thing as well as an art object. To make something that was a reconciliation at a higher level—that was my conceit. Not some artwork that was referring to mass production, or vice versa, but something that reconciled both forms of expression into a single form. And I began to think about how many ways industrial production seeks to imitate nature, for instance, in its repetition, in its fecundity, and in its quantity.

There is something so sensual and almost mind-boggling about the *Individual Works.* They are designed to appeal directly to a sense of touch with all of those little shapes that are so eroticized. There seems to be so much reference to the body. When I looked at the table filled with over ten thousand works, I felt like there was an extension or a projection of the human body, in a sense, my own body—not only because I'd touched each one and made each one but because the little shapes often resembled little penises or little nipples or other little bodily passages. I borrowed from industrial design all those little tricks that make you want to touch something, that appeal to your sensuality and your desire. I chose to make shapes that, in a similar way to the *Perfect Vehicles,* could appear both biomorphic and mechanical.

When I made those salmon-colored *Individual Works* I expected that they might have the effect of synthetic intestines. I was looking for a color that would resemble synthetic flesh, so the table would almost look like an operating table, a mechanized depiction of a dissection table that had gotten out of control. In the same sense, I chose green for the other ones so they'd refer to vegetation and growth.

Tom: Like scenarios in a horror film?

Allan: Well, I suppose.

Tom: That they might hatch or something?

Allan: Well, that could be. To me that's the way the world looks; that's the way industrial production seems—kind of maniacally proliferate. At the same time it seems almost to want to reach for the sublime, to represent our wishes for abundance: to heal the sick and feed the hungry and to produce a more egalitarian society. All these feelings go hand in hand with our horror of technology and weaponry. Industrial production certainly isn't without its emotive qualities. It is clearly a reflection of our dreams being made real in some way, and our nightmares.

Tom: There's the argument that art is useless whereas the industrial object is useful. You work with industrial techniques—from a kind of mechanical drawing to assembly-line production—to make objects that are designed to have no use.

Allan: Well, I think that's a particular way of looking at use. There is, of course, already such a thing as the mass production of art objects. If that's someone's definition of industrial mass production, then it shouldn't seem possible to produce art objects industrially. But people do this all the time. They produce souvenirs and tchotchkes and religious symbols and so forth. It's very common that we produce objects that are

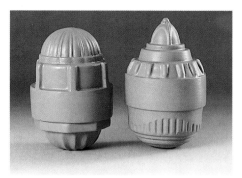

Over Ten Thousand Individual Works (detail), 1987–88, enamel on cast Hydrocal, approximately 2 x 5 inches each. Photo: Fred Scruton.

for symbolic and aesthetic use. I make a special point with the *Individual Works* to make sure that they are not useful. They don't even have bottoms, so they can't be used as paperweights. That's something that I had to figure out, and it was much harder making them without bottoms because they needed a two-part mold, and they'd roll off the table during production. In many ways, I really like this work because these objects are an attempt to come up with your "basic treasured object." I had this continuum in my mind: I had the feces of the toddler at one end of the spectrum (which might be the first valued object) and the Fabergé egg at the other end. And in making all these design choices there was that intestinal quality.

Tom: From the chicken's point of view?

Allan: A Fabergé egg is essentially an object of pure value, maybe even to the chicken [laughs]. The process of producing the *Individual Works* in quantity becomes part of the drama of experiencing the work, I think. It certainly does for me. And I produced those *Individual Works,* of course, without ever seeing them on display because I don't have room to display them. So they're made on a table and then put into boxes.

Tom: In your studio, where they're made on trays like cookies, that gives you one sense of what they might be, yet the end result is different.

Allan: To this day, I honestly don't know what to do with them. Two different museums bought groups of over ten thousand. I've made over thirty thousand so far. Ten thousand seems to be the low end of what they call a short run in industry.

Tom: In a funny way it seems like an excess, but it's really not at all.

Allan: That's true. Once I had a job for somebody else, and I had to come up with twelve hundred wooden pegs of an odd size. I didn't want to make them myself so I looked in the Yellow Pages for people who did wood turning and found a company whose claim was that there was no job too small. They said they did short runs. So I went all the way over there and told them I wanted twelve hundred pegs made, and they said, "We won't do twelve hundred objects." And I said, "You said, 'No quantity too small.'" They said, "Yeah, but twelve hundred?" I asked, "What's a short run?" And they said, "It would have to be at least ten thousand."

But the effect of the *Individual Works* is peculiar because they create something like a moral problem. I created a system that produced them all to be unique, which is all very intellectual, arithmetic. Once they're all out on the table, then they're an experience that I find unsettling. Sometimes I find it exalting and sometimes I find it nauseating, especially when, for instance, I've started to look to see if I can find the one that I'm looking for. There's just so many discriminations that have to be made that I start feeling nausea.

Tom: Can you remember each one?

Allan: I remember the molds. I've made only about three hundred molds. Each mold creates half an object—they go together in over forty-five thousand ways. When and if I produce more molds, the yield will rise exponentially. I certainly could say to myself that I would like to find the one that has such and such a top and such and such a bottom—I could do that. A lot of the objects, the little shapes and parts that I use, have personal significance to me. They come from very specific moments, like the object you have—one of the shapes came from a friend's childhood toy and another shape came from my flashlight. I've used the shapes of objects found on friends' front yards, or in friends' houses, on trips abroad, vacations, hardware stores in Europe, so that when I look at that vast array of unique objects—*Individual Works*—I'm also experiencing a flood of memories as well.

I find that the work replicates a kind of day-to-day drama. It's a moral drama. It's making decisions about what's important and what isn't: what people are important, what people aren't important; what things are important, what things you throw away, what things you keep; what person you want to talk to and who you

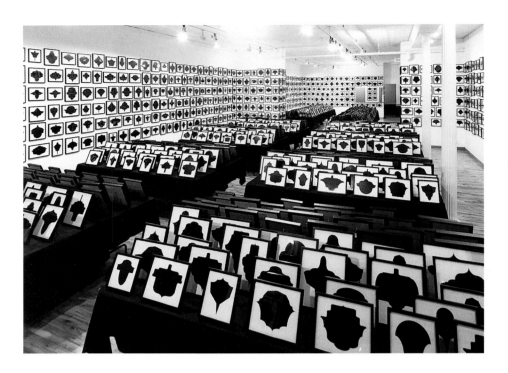

Drawings, 1988–90, artist's pencil on museum board. Installation site: John Weber Gallery, New York City, 1990. Photo: Fred Scruton.

don't; who your friends are. These constant choices we make in a field of billions of people are probably essentially experienced on some level as a kind of moral pain, like the pain suffered by a military officer when he decides to send soldiers into battle knowing that a certain percentage of them are going to be killed.

And I think that in a sense this moral pain is what *Individual Works* are a "picture" of. I also think it's the same moral pain represented by the whole continuum of objects, from the mass produced to the unique, from the common to the rare, and so forth, because I think this continuum obviously (maybe not obviously) represents the way we construct a class society. The way this society is organized, the way we organize objects, reflects the way we are organized by society.

I have to say, there's an effect that I try to achieve with my work.... Have you read *Jealousy* by Robbe-Grillet? I don't believe the word *jealousy* is ever used in the book, in spite of the title. All you experience as a reader is the narrator's description of what he is looking at. He's looking at the trees and he's looking at the veranda and he's looking at the letter in his wife's handwriting that he sees in his friend's pocket. He thinks, Maybe... And there's this obsession with looking that's described over and over again as his eyes go back to certain things and to his memories of seeing certain things. He's jealous, he's frightened, he's angry. You intuit those emotions; you're not told he feels this way. The feeling grows in you as you're reading, as the character increasingly "looks" at things in a way that's conditioned by his feelings. I was hugely influenced by Robbe-Grillet in the sixties. And I think it's that way of developing emotional self-consciousness that I try to accomplish—that it isn't located in the objects; it's a kind of halo effect that emerges in the experience of the objects. It's a recognition of something unconscious that slowly emerges, so that the pain of social inequity is replicated in the way we organize objects. One of the things I'm doing with the *Individual Works* is trying to re-create that drama. This is the kind of effect that I try to achieve with my work: how I described looking at ten thousand objects as nausea or moral pain.

Tom: Do the *Drawings* refer to moral pain as well?

Allan: The *Drawings* and the *Individual Works* were born out of each other; they were similar projects. The *Individual Works* came first. I wanted to speak about the impulse to do these projects in the terms you brought up earlier, about representation versus antirepresentation. The *Perfect Vehicles,* in a sense, represented a very specific type of symbol, which you could define as a single object that might represent "eternal truths." That's a common type of symbol—a single thing that represents a lot.

(a)

I think I wanted to question or explore this particular structure: one thing representing everything. We look at the American flag and it represents all Americans or the "Spirit of America," or whatever. What if instead we had 300 million individual symbols that somehow represented the multiplicity of the country? I wondered if there wasn't some kind of hierarchical thinking or aristocratic model that we follow in the way we make objects and organize them when we create symbols. It almost seems to be our primary definition of a symbol—that it represents something larger than itself. Otherwise you wouldn't need the symbol; you'd just have the thing itself.

So I was thinking about how difficult it is for us to conceive of the quantity of people on the planet and how before we knew how to conduct demographic studies, no one knew how many people were on the planet, and this was a mysterious concept. But with communications as they are now, it's a serious emotional problem, dealing with the knowledge of how many people are on the planet and what it means when we hear that twenty thousand people died in an earthquake. It's difficult; it's a moral problem.

I began to wonder if maybe part of that problem is that it's exacerbated by the structure of our symbols, where one object represents many things. Maybe an alternative or additional kind of symbol making could exist where thousands of things were represented by thousands of things. I wondered what that would look like. I was thinking about people when I designed the *Individual Works:* what people must mean when they talk about the human soul, individual souls, and how you would depict that. With the *Drawings,* I chose this kind of heraldic image that might even suggest a clan or family symbol but carried that idea through into a slightly more complex system that could produce millions and billions of separate images—potentially one for every human soul on the planet. In a sense, I was creating a heraldic system for individuals rather than for families or nations. With both of these projects I'm dealing with huge quantities. I mean, the *Individual Works* are being shown in lots of over ten thousand, and the *Drawings* are shown with as many as twenty-five hundred in one exhibit. I hoped to create a picture of what it might look like if we thought differently about making symbols in the first place.

Tom: How did you go about making the *Drawings?*

Allan: I designed five curves and a system of formats or little matrixes. I inscribe these curves into the matrixes and use an arithmetic system to make sure that I don't repeat myself. Then I draw these five curves in every combination on paper. So far, I haven't made a drawing with more than four curves.

Tom: Do the curves have personal references for you the way the forms making up the *Individual Works* do?

Allan: No, they're just geometric. I had plastic templates made at a factory where they make architectural templates out of that green plastic. But, no, they don't have any of that kind of significance for me.

Tom: The piece is more diagrammatic, in a sense. The *Individual Works* seem to spin off from all these other associations, but the *Drawings* focus in on the idea in a more abstract way.

Allan: There was so much hyperextended sensuality in all those multiple references in the *Individual Works.* I think that with the *Drawings* I was looking for something that was balanced and stable, so I chose symmetrical shapes and a traditional art medium. It was the only series I've ever done using a traditional art form: graphite on paper. That's why they're simply called *Drawings.* In a sense, it was about the desire to look for social stability through identification, hence the reference to heraldry—about making a stable symbolic system to accommodate the chaos of huge numbers.

(b)

(a) *Drawing,* in progress. Photo: Roddy Bogawa (b) *Drawing,* 1988–92, artist's pencil on museum board. Photo: Eric Baum.

(a)

(b)

(a) Scene from *The Kitchen,* by Arnold Wesker, 1959 (b) BMPT (Buren, Mosset, Parmentier, Toroni), *Manifestation No. 3,* theater performance, 1967. Musée des Arts Décoratifs, Paris.

Tom: The *Drawings* are much more austere in appearance than the colored plaster works.

Allan: When I walk into exhibits of my drawings, I feel like I'm walking into an ancient archive. There's a kind of spiritual stability in them for me, whereas the *Individual Works* are transgressive in all different kinds of ways.

Tom: The *Drawings* are harder to gain access to; they're just there. With the objects it's obvious that you have a real desire to tell stories, to insert a narrative content in the work. And while looking at these objects, people have these realizations about different kinds of moral situations, or realizations about the passage of time. I think making narrative, representational paintings is no longer feasible, or reliable, or doable. It seems that now we need to make movies, or get into some kind of elaborate installation type of work, or some kind of time-based work if we want to tell a story. But you've been able to do it in this perverse way by holding on to "traditional" cultural objects like the vase. You've been able to get this poignant effect from a group of things that, on the face of it, shouldn't produce that effect.

Allan: Before I was an artist, in the early sixties, I thought that maybe I wanted to go into theater and had gotten a bit interested in writing plays. There was one play I never saw produced but I read it—*The Kitchen* (1959) by Arnold Wesker. Do you remember it? It was a one-act play structured on the rising tension and stress that takes place in a restaurant kitchen as the rising demand for producing food and getting it out there during a rush takes place. I'd worked in a lot of restaurants and knew this structure, so I was intrigued by this play. It depicted the increasing tension between the employees: increasing anger, increasing arguments. In the end it calms down, back to normal, and you get the sense that this happens every four hours. That was the play, sort of "found theater." It was an allegory for the way working people are caught up in the drama of economic demand and endless production. All the characters were cooks and waitresses—it was a wonderful play.

This particular drama had such an influence on me. Reading John Cage, I noticed how he would substitute other sequences of events for traditional musical structure. I was attracted to that as well. After learning about the wide variety of Fluxus performances based on the substitution of nonnarrative "events" for traditional storytelling, I quickly fell into imitating the task-oriented performance in my studio. So the objects that I produce are always the result of multiple sets of applications of simple tasks.

One performance that has stayed in my mind was the one by Yvonne Rainer where she and a group of dancers carried furniture and carpeting from the lobby of the theater to the stage, and that was it. She did many other performances that challenged preconceived ideas about narrative. Carrying furniture from one place to another is only a narrative if you really want to think of it as a narrative. In fact, there may be no other way for us to perceive any sequence of events, really.

I think the question for me was, "Where does that narrative structure exist?" Does it exist in the event? in the script? in your head? In the sixties this was a very crucial question. Many people were interested in the nature of what we universalized as in-the-world as opposed to invented cultural structures. Is the narrative scenario something that is universal, or is this in the event itself, or is this something that we bring to events? These were the kinds of questions that a lot of people were asking. I was also especially influenced by a group of radical performance artists in San Francisco who called themselves The Diggers. I never met these people; I just remember anecdotes. But they invented the Free Store. Do you remember that?

Tom: No, that is too much a part of American history for me.

Allan: These actors were interested in artistic social intervention. I believe they were actors who had studied Brechtian strategies. They were interested in

economics, and they were interested in how we perceive one another in the economic world that we live in and how we function there. They came up with this series of quasi-theatrical interventions that invited or forced you to consider economic exchange as a possible site of creative awareness and change. That was one of their strategies—just to use the word "free" and attach it to things. Especially things such as "free love" that were already free, so there was an obvious and paradoxical irony. Or the Free Store: it was a real store that opened in a storefront and everything was free. They spent a lot of time going around to bakeries and meat markets in the middle of the night and finding things that people didn't want, soliciting donations from all over the city.

Tom: Real things were free?

Allan: Real things. You'd go in there and get food or clothes or whatever they were able to come up with. I guess the idea of a store where you get something for free is only appreciable in terms of knowing about the enormous amount of trouble it was to keep the store functioning. And that's what I mean by a story. It's that sense of a drama that only becomes radically moving if you know what it took to make it happen. Getting up at three in the morning every day and going out to all the bakeries…

Tom: So this is different from Oldenburg's store?

Allan: It was very different, although it could have been influenced by that. It seemed to be an attempt to question what certain forms of economic exchange signify. Our traditional economic concepts limit our ideas about what's possible. The Free Store suggested a more creative way to look at what a store might be and to generate all kinds of implications as to other kinds of "valuation." I was struck by this experiment.

Tom: Did you know about Oldenburg's store at that time? I ask since he made plaster objects. Did you know about that wedding-cake piece he did in L.A. in 1966—plaster cake-slice souvenirs for a curator's wedding party?

Allan: I didn't know the whole story until I read it in your essay! [in Claes Oldenburg: *Multiples in Retrospect 1964–1990* (New York: Rizzoli International Publications, Inc., 1991)].

Tom: That was one of Oldenburg's best multiples. I especially like that the guests at the wedding party took away their slices as party favors.

Allan: Me, too. In my own work the way art circulates among people is really primary in my thinking. Artworks sometimes seem to be just like tokens, or coins, circulating from person to person, or from gallery to museum to auction house. They accrue meaning and value at every step. Circulating like coins but much more slowly, of course, and on an entirely different historical scale. But they're always *moving*. They always have a kind of trajectory, and this trajectory develops the meaning of the work and one's experience of it.

Also in the sixties, around 1967 or '68, I remember reading about an event staged by the BMPT group in Paris. Each of the four members of the group had their own particular abstract painting that was reproduced over and over again as a group. The paintings themselves were indefinitely reproducible, depending on the circumstances they were shown in. In this particular event they displayed one each of their four paintings—each the same size—on a theater stage, and invited an audience to view them. The curtain went up for one hour, and then it came down. That was it. They isolated the event of looking at a painting as a single dramatic moment.

Reading about this event had an early effect on my thinking. I was interested in ways to isolate the act of looking at a painting from the actual painting itself. This thinking really culminated when I began doing the *Surrogate Paintings*: the

painting as a token, a sign of itself, or a prop, around which meanings and desires play out some kind of drama.

Tom: But it has always seemed to me that the positions staked out by Buren and Mosset and the others are always just that—positions taken, poses struck. I have always found it difficult to accept the political content in the work of radical-chic intellectuals with an eye to career improvement. You, at least, have the desire to reach out to the common person, the uninitiated person who's not an art lover. The very particular decisions that you've made all along have been much broader in their implications.

Allan: Well, these artists have always been really important to me. I'm sure my mentality and my background are different, and maybe I do imagine a different kind of audience when I'm working. I don't really know. But their work means a lot to me. I'm glad you think that, though. In other words, you don't think that a person needs to have followed art closely to feel like there are issues they can relate to in what I'm doing?

Tom: I think that the *Surrogates* still operate in that space where they look a little like abstract paintings. Big installations of them, where you had five hundred or so on the wall, probably transcended that. It is such an obsessive and absurd experience that there is a good chance that even someone who doesn't know the particular crevices of the argument might get a sense of what is going on. I think with the *Perfect Vehicles* it becomes clearer because they're not art objects per se; they refer to these vast cultural and emotional constructs that more people are likely to have a memory of, or a knowledge of, than of painting or art history. In the *Individual Works* the objects are recognizable in a way, but you don't know what they are, or you can't pin them down as art. They're not recognizably art. They're recognizably something else.

Allan: I agree.

Tom: Because the *Individual Works* don't have bases, they're not sculptures. They don't have hooks on the backs, so they're not paintings. They're homeless. The more recent pieces, *The Dog from Pompei* and the *Lost Objects,* are very direct.

Allan: It's back to what you said at the very beginning. The works seem to want to leapfrog over art history in their effect. Is that what you said?

Tom: I think they do manage to get past the complexity that modernist avant-garde activity has created—the reliance on a complex barrier to understanding as part of its method of working. Starting from a very valid premise—questioning an issue of culture—such work has created a situation that's possibly worse than what it sought to fix. Oddly, there lies the place for reinscribing recognizable objects into the discourse, a strategy which obviously plays into the difficulties of being retrograde. So the question is, are you advancing or retreating when you start making work that can be described as figurative?

Allan: I don't think that's the issue! Especially at this point in time. I don't know that it makes sense anymore to say that the main barrier separating modernist avant-garde artwork from the majority of people is that these works lack imagery, or that they're nonrecognizable, or anything like that. I think that the key to this separation lies more in the quantity, or the lack of quantity, of these artworks. I mean, artists seem to have just accepted, without question, that it's their calling to produce *rare* objects. This seems to me to be the reason that avant-garde activity is isolated from the people at large.

These days it's possible to learn about the philosophical complexity of all these "issues" on your own from reading and visiting museums and so forth. People aren't stupid. But what really is a barrier, I think, is this focus on making rare artworks that preclude participation by the majority of people through any real ownership and (worst of all) by censoring objects created in larger quantities before

they're even made. We always seem to reinvent a class system of objects to accommodate the already existing class system, and I think this artificially limits what we're able to express as artists.

It's so funny the way people think. What might be considered to be beautiful in a small quantity of one or two is supposed to become less beautiful in larger quantities. And in mass quantities, things can even begin to seem hideous to some people, especially to connoisseurs, and "common" clearly becomes a negative, not a positive, quality. So when artists try to be progressive and at the same time produce rare objects, I think they are often working against their own stated intentions whether they mean to or not. I think they operate out of a blind spot.

Tom: I tend to agree. Susan [Morgan] and I have a friend who trades in craft items from Central and South America—beautiful things and silly things, well made and improvised. She is fond of saying that while she admires quality, she loves quantity. I think that this—Claudia's dictum—expresses a kind of joyfulness, an acceptance of difference that has to be at the heart of any progressive idea of art making.

Allan: It's a shame the way artists are always letting themselves be maneuvered into making these objects, objects which are meant to function in this kind of role. It doesn't even necessarily make sense, this idea that beautiful things should only be made available in small numbers. Yet in the art world we seem to accept this limitation without much question.

In the everyday world, we all know that a large quantity of anything can be regarded as beautiful. Everyone loves to watch the clouds, for instance, which are always unique and constantly plentiful. And we all seem to agree that trees are beautiful, and flowers and grains of sand and all the other millions of unique biological and geological formations around us. So in everyday experience there just doesn't necessarily seem to be any conflict between what's common and plentiful and what's unique and irreplaceable when it comes to designating beauty.

I think that we all lose out when we ask our artists to eliminate their feelings about large quantities from their vocabulary of expression just to please a certain exclusive group. And for this reason I think it's really important that as artists we should feel free to take a stand on this point by making as many artworks as we want.

■

Thomas Lawson, *Viennese Fantasy No. 4,* 1994, acrylic on canvas, 54 x 73 inches.

Since the completion of this interview in 1992, the artist has produced a new series of works titled *Natural Copies from the Coal Mines of Central Utah,* pictured in this book starting on page 89.

EARLY WORKS

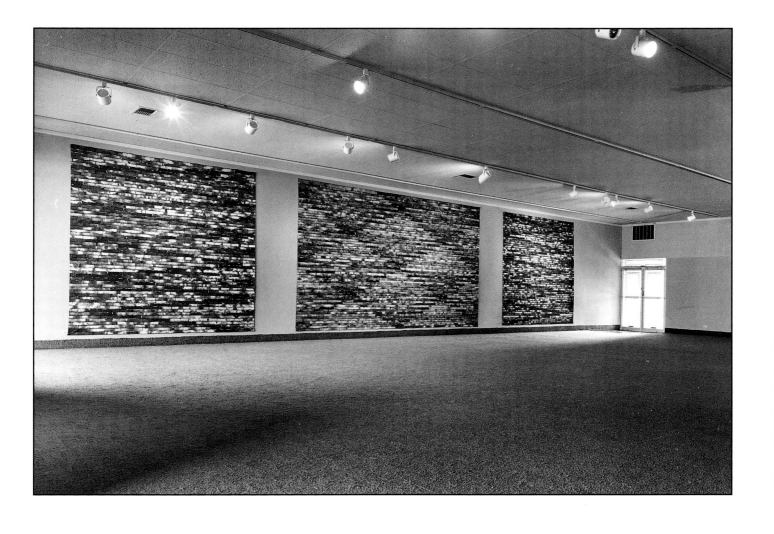

Bleach Paintings
series begun in 1969

The *Bleach Paintings* are
made by first dyeing a
stretched or unstretched
piece of canvas with gray
dye, masking off a series of
linear stripes with tape, and
then pouring household
bleach over the entire
surface. When the masking
tape is removed, a linear
pattern is revealed which
has been formed by the
disappearance of the gray
dye where the bleach has
soaked into the canvas.
The *Bleach Paintings* have
sometimes been made on
small cotton handkerchiefs.

(a)

(b)

(page 31) *Constructed Paintings,* 1970–71, canvas, dye,
caulking. Installation site: Jack Glenn Gallery, Corona Del
Mar, California, 1971. Photo: Jerry Muller.

(this page) (a) *Untitled Painting,* 1969, dye and bleach on
handkerchief, 15⅝ x 15⅝ inches. Photo: Fred Scruton
(b) *Untitled Painting,* 1969–70, dye and bleach on canvas,
90 x 102 inches. Photo: Frank J. Thomas.

(a)

Constructed Paintings
series begun in 1969

The *Constructed Paintings*
are pieced together from
rectangular sections of
canvas. Each canvas section
is individually coated with
dye, paint, sand, or other
material and attached to the
next section with rubberized
caulk. A numerical system is
used so that the assembly of
each *Constructed Painting*
forms a pattern that is
different from every other in
the series.

The *Constructed Paintings*
are stapled directly to the wall
and can be made as large as
the strength of the materials
will allow.

Preprepared 6-inch canvas squares, used to
assemble *Constructed Paintings.*

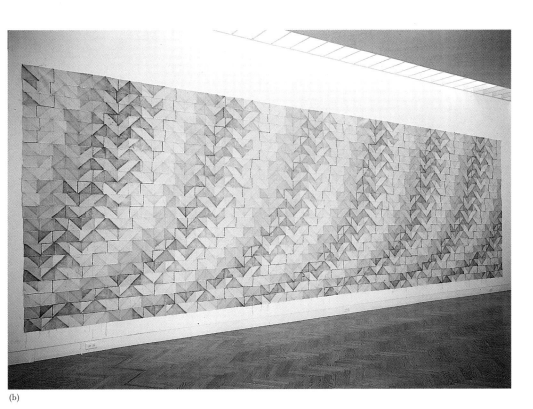
(b)

(a) *Constructed Painting*, 1970–71, canvas, dye, caulking.
Photo: Frank J. Thomas. (b) *If Love Had Wings: A Perpetual
Canon*, 1972. canvas, caulking, lacquer, varnish, 9 feet 2 inches
x 27 feet 7 inches. Installation site: Pasadena Art Museum,
1972. Photo: Frank J. Thomas.

Untitled Paper Constructions
series begun in 1974

The *Untitled Paper
Constructions* are pieced
together from sixteen basic
shapes that are first drawn
on graph paper and then
commercially printed on
bristol drawing paper.
Each shape is torn out by
hand and covered with
pencil or paint. The shapes
may be pieced together to
form an indefinite number
of different paintings and
drawings of an indefinite
number of different sizes.

Printed shapes used to generate *Untitled
Paper Constructions,* offset lithography on
drawing bristol. Photo: Fred Scruton.

(a)

(b)

(c)

(d)

(a) *Untitled Paper Constructions,*1974–75, acrylic on 192 paper
shapes glued together, 16⅛ x 24 inches each (b) *Untitled Paper
Constructions,* 1974–75, acrylic, pencil, and watercolor on
paper, 16⅛ x 24 inches each (c) *Untitled Paper Construction,*
1974–75, acrylic on 96 paper shapes glued together, 16⅛ x 24
inches each. Photo: Fred Scruton (d) *Untitled Paper
Construction,* 1974–75, acrylic on 96 paper shapes glued
together, 16⅛ x 24 inches each.

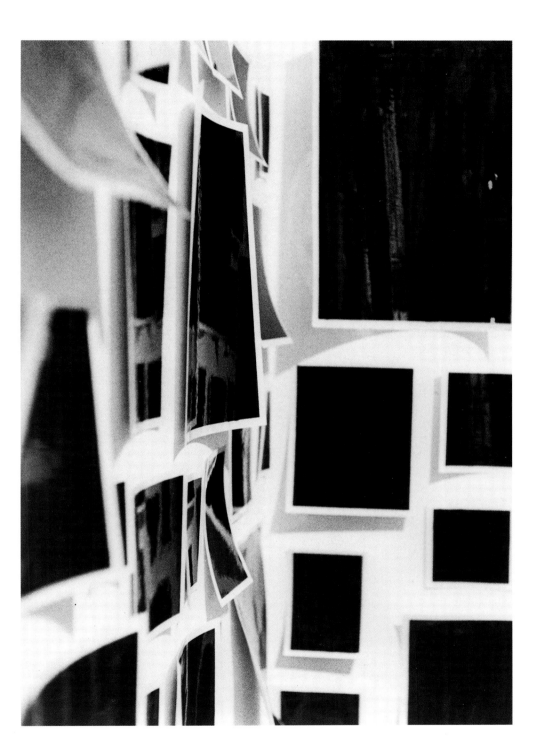

Glossies
series begun in 1980

The *Glossies* are made with ink and watercolor on bristol drawing paper. Each one is then covered with a self-adhesive plastic laminating film. The *Glossies* are accumulated in collections the way old snapshots are gathered in shoe boxes.

Glossies (detail), 1980, ink and watercolor on paper with self-adhesive plastic laminate. Installation site: Dioptre, Geneva, 1981.

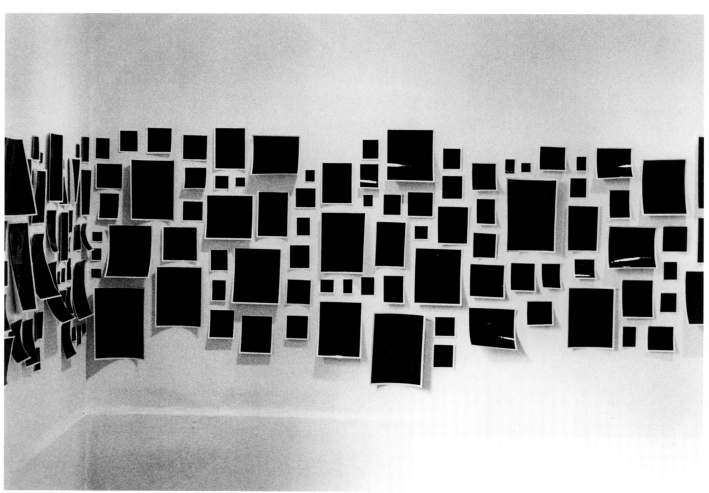

(a)

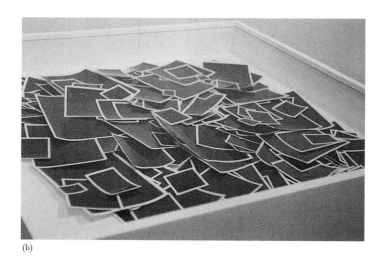

(b)

(a) *Glossies*, 1980, ink and watercolor on paper with
self-adhesive plastic laminate. Installation site: Dioptre,
Geneva, 1981 (b) *Glossies,* 1980, ink and watercolor on paper
with self-adhesive laminate.

COLLABORATIONS

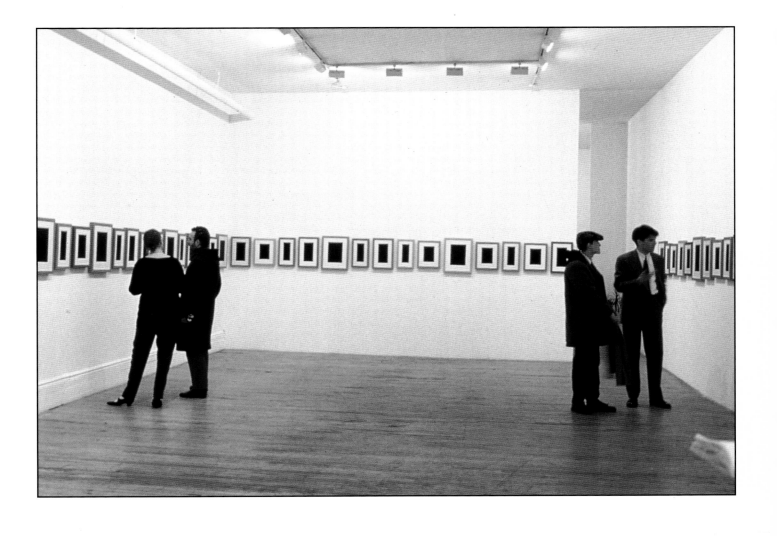

Ideal Settings
series begun in 1983
(in collaboration with Louise
Lawler)

The *Ideal Settings* are objects
that resemble small sculpture
bases. Usually cast in gypsum
from rubber molds, they are
colored black for presentation
and display.

(a)

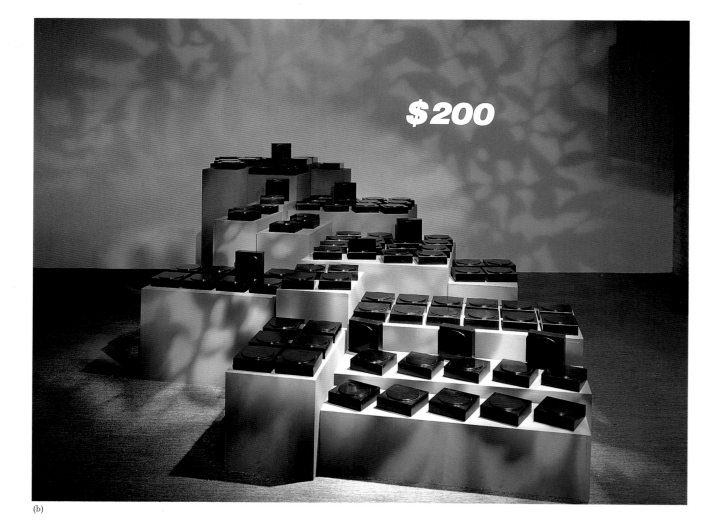

(b)

(page 37) *May I Help You?* Andrea Fraser performance
in cooperation with Allan McCollum, 1991.
Installation site: American Fine Arts, New York City.

(this page) (a) *For Presentation and Display: Ideal Setting,* 1983,
lacquer on cast Hydrocal, 7 x 7 x 2 ³/₄ inches. Photo: James
Welling (b) *For Presentation and Display: Ideal Settings,* 1983–84,
one hundred cast Hydrocal sculpture pedestals with slide projec-
tion and theatrical lighting. Installation site: Diane Brown Gallery,
New York City, 1984. Photo: Jon Abbott.

Actual Photos
series begun in 1985
(in collaboration with Laurie
Simmons)

Tiny human figures
produced for model train
setups are purchased
from the hobby shop and
photographed just as they
come out of the package.
They are shot through a
microscope at a local
hospital's pathology lab.
The heads in the *Actual
Photo* portraits are in reality
no more that two millimeters
in diameter.

(a)

(b)

(c)

(d)

(a) through (d) *Actual Photos,* 1985, Cibachrome, 10 x 8
inches each.

Fixed Intervals
series begun in 1988
(in collaboration with
Louise Lawler)

The *Fixed Intervals* are
tiny graphic symbols, or
dingbats, enlarged to about
eight inches high. They
are sometimes cast in
gypsum from rubber molds
and sometimes cut from
metal. A *Fixed Interval* is
mounted on a wall to take
the place of an artwork that
is missing.

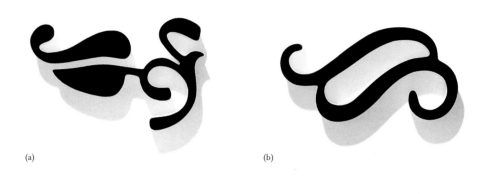

(a) (b)

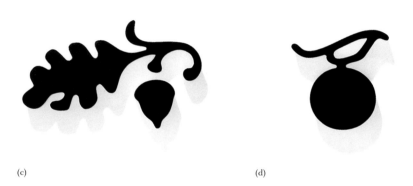

(c) (d)

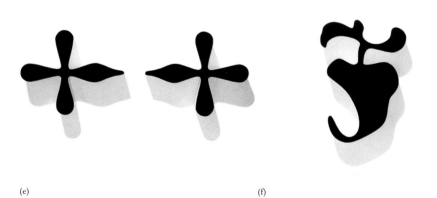

(e) (f)

(a) *Fixed Interval*, 1988, enamel on Ultracal, 8 x 5⅝ inches (b) *Fixed Interval*,
1988, enamel on Ultracal, 8⅜ x 5¼ inches (c) *Fixed Interval*, 1988, enamel on
Ultracal, 5⅜ x 7¾ inches (d) *Fixed Interval*, 1988, enamel on Ultracal, 4⅞ x 4½
inches (e) *Fixed Interval*, 1988, enamel on Ultracal, 10 x 4¼ inches (f) *Fixed
Interval*, 1988, enamel on Ultracal, 8 x 5⅝ inches.

SURROGATE PAINTINGS
AND
PLASTER SURROGATES

Surrogate Paintings
series begun in 1978

The *Surrogate Paintings*
are made from wood and
museum board glued and
pressed together and painted
all over with many coats of
paint. Each *Surrogate
Painting* varies in size.

Surrogate Paintings, wood and museum
board. Photo: Eric Baum.

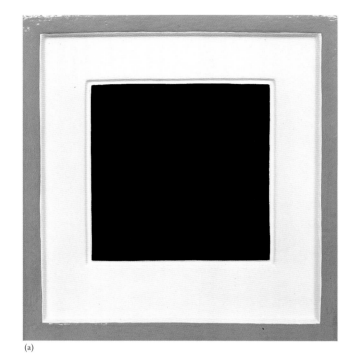

(a)

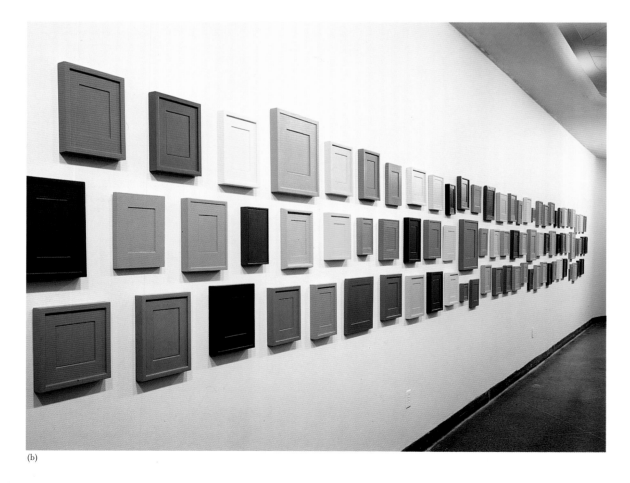

(b)

(page 41) *Plaster Surrogates*, 1982–84, enamel on cast Hydrostone.
Installation site: Richard Kuhlenschmidt Gallery, Los Angeles, 1984.

(this page) (a) *Surrogate Painting*, 1978–80, acrylic on wood and
museum board, 7¾ x 7¾ inches. Photo: Fred Scruton (b) *Surrogate
Paintings*, 1978–80, acrylic and enamel on wood and museum
board. Installation site: 112 Workshop, New York City, 1980.
Photo: eeva-inkiri.

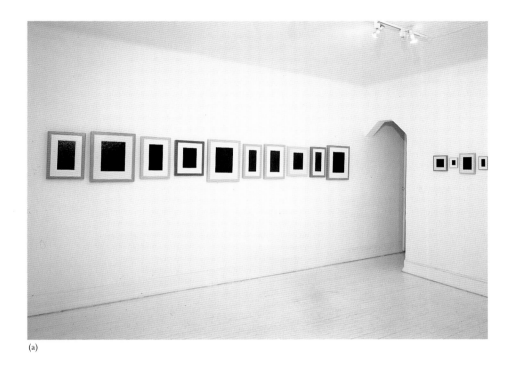

(a)

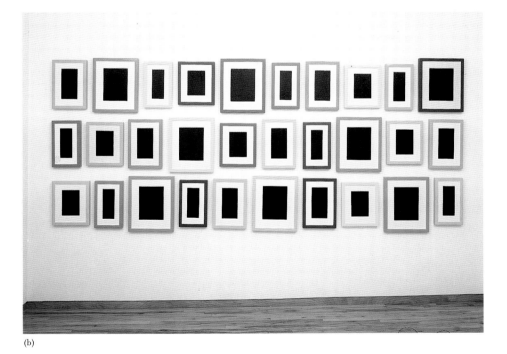

(b)

Plaster Surrogates
series begun in 1982

The *Plaster Surrogates* are
cast in gypsum from rubber
molds taken from selected
Surrogate Paintings. They
are painted all over with
many coats of paint.

Plaster Surrogates with
black centers are given
different colored mats and
frames. There are about
twenty different sizes of
Plaster Surrogates painted
with about 140 different
frame colors combined with
a dozen different mat colors.
These combinations can
produce many thousands of
unique works. The works
are grouped into many
collections of different
numbers.

Mold for *Plaster Surrogates,* polyurethane
rubber and acrylic plastic. Photo: Eric Baum.

(a) *Ten Plaster Surrogates*, 1982–90, enamel on Hydrostone.
Installation site: Julian Pretto Gallery, New York City, 1989 (b)
Thirty Plaster Surrogates, 1982–90, enamel on cast
Hydrostone. Installation site: John Weber Gallery,
New York City, 1990. Photo: Fred Scruton, courtesy of John
Weber Gallery.

(pages 44–45) *Plaster Surrogates*, 1982–84, enamel on
Hydrostone. Installation site: Cash/Newhouse Gallery,
New York City, 1985. Photo: Bill Jacobson.

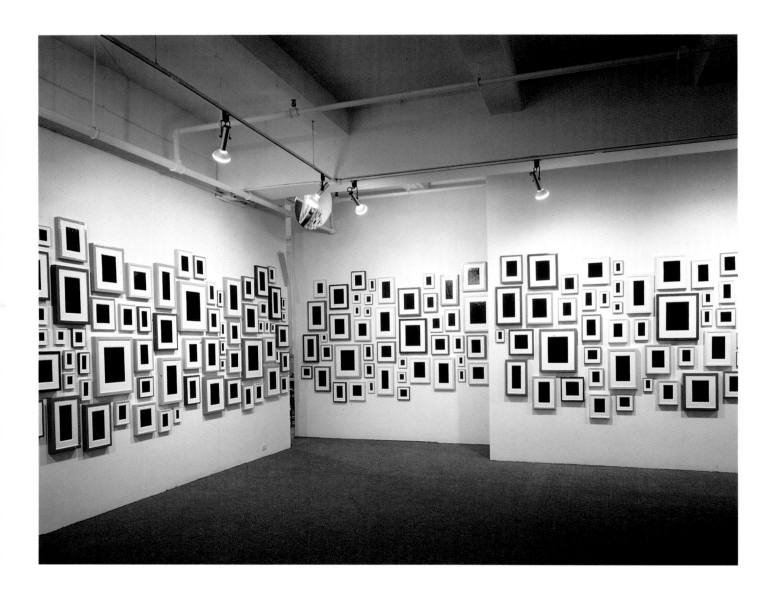

Plaster Surrogates, 1982–83, enamel on Hydrostone. Installation
site: Marian Goodman Gallery, New York City, 1983.

PERPETUAL
PHOTOS

Perpetual Photos
series begun in 1982

A snapshot is taken from the television screen when a framed artwork is seen on the wall behind the dramatic action. The *Perpetual Photos* are these artworks enlarged again to a normal scale and reframed by the artist for re-presentation in a tangible setting. Each *Perpetual Photo* is completely unique, and an endless number of different *Perpetual Photos* remain to be discovered and produced.

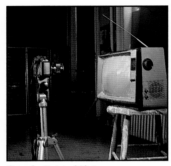

Setup for *Perpetual Photos*.

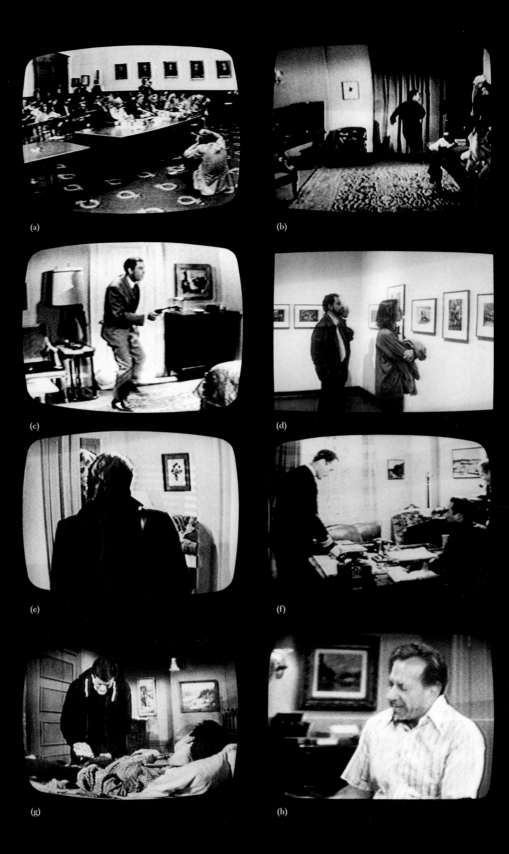

(a) (b)

(c) (d)

(e) (f)

(g) (h)

(page 47) *Perpetual Photos*, 1982–89, silver gelatin prints.
Installation site: John Weber Gallery, New York City, 1989.
Photo: Fred Scruton.

(this page) Sources for *Perpetual Photos:* (a) *No89E*
(b) *No. 10* (c) *No. 21* (d) *No. 217B* (e) *No. 119*
(f) *No. 145* (g) *No. 126B* (h) *No. 4*.

(a)

(b)

(a) *Perpetual Photo (No. 89E)*, 1985, silver gelatin print,
10 x 8 inches (b) *Perpetual Photo (No. 10)*,1982–85, silver
gelatin print, 10 x 8 inches.

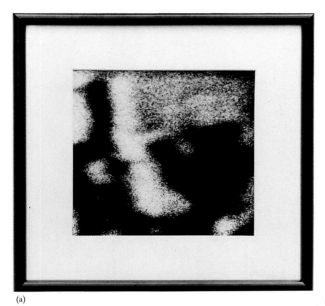

(a)

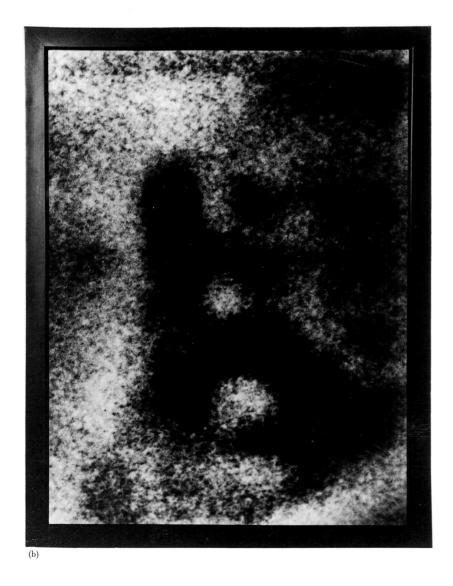

(b)

(a) *Perpetual Photo (No. 21)*, 1982–86, silver gelatin print,
13 x 13½ inches (b) *Perpetual Photo (No. 217B)*, 1982–90,
silver gelatin print, 54½ x 45 inches.

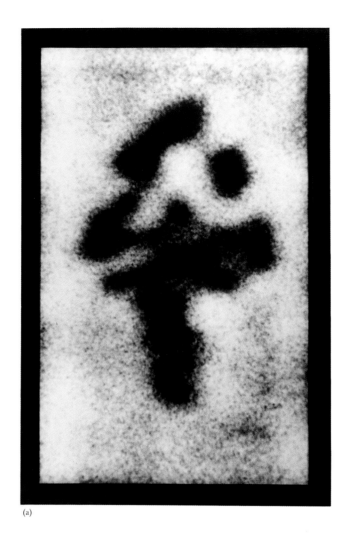

(a)

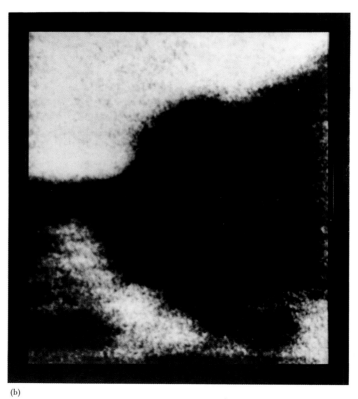

(b)

(a) *Perpetual Photo (No. 119)*, 1984–86, silver gelatin print,
62 1/$_2$ x 39 inches (b) *Perpetual Photo (No. 145)*, 1984–86,
sepia-toned silver gelatin print, 42^1/$_4$ x 37^1/$_4$ inches.

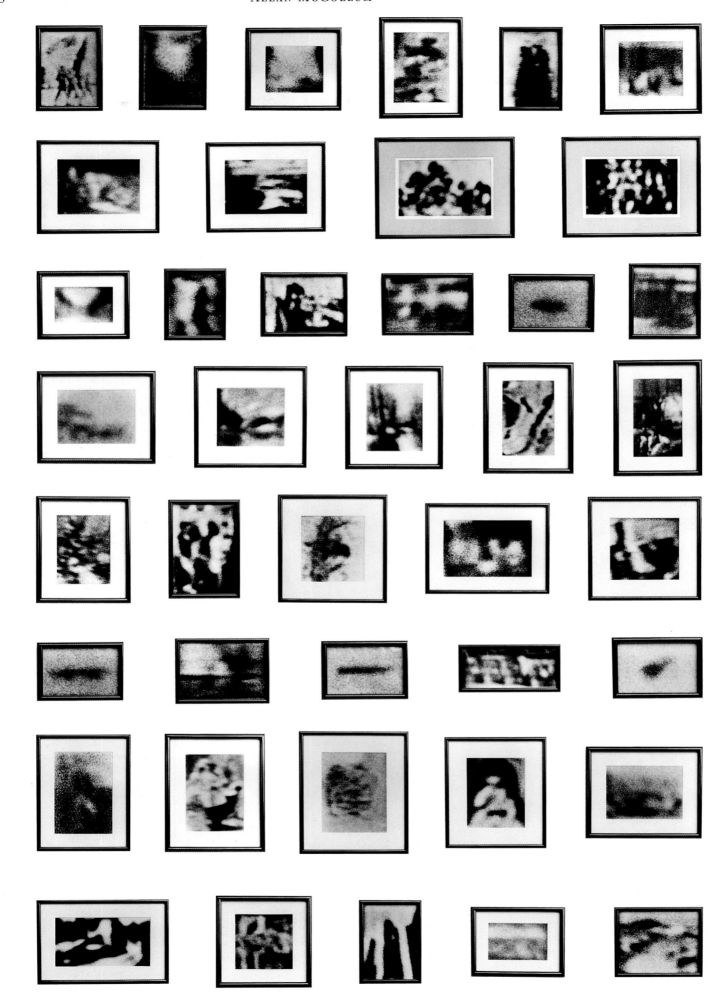

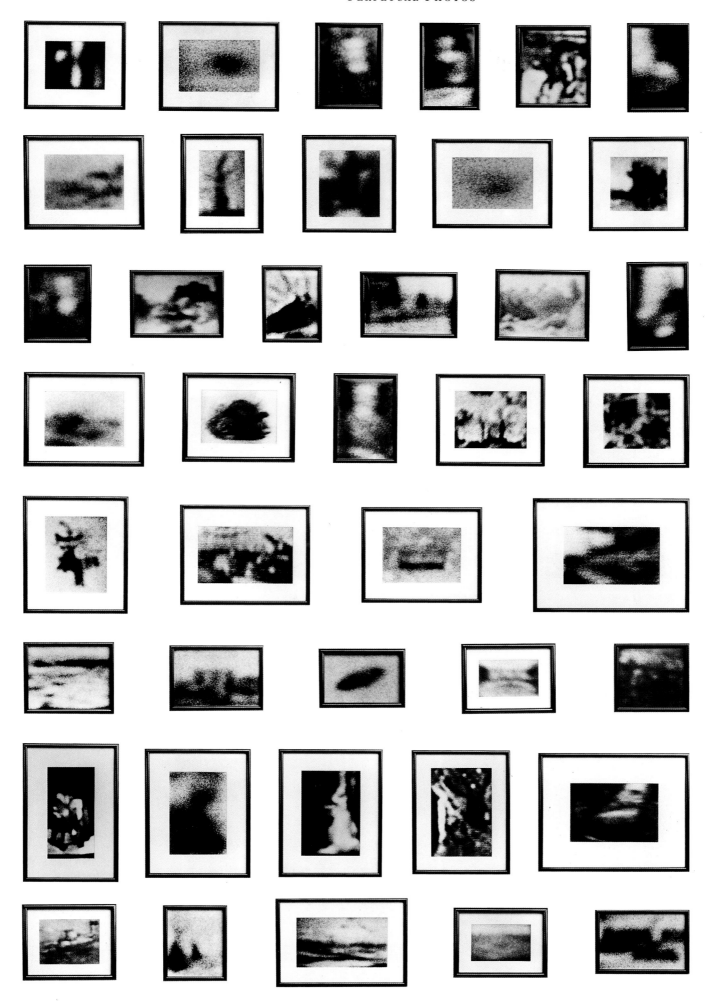

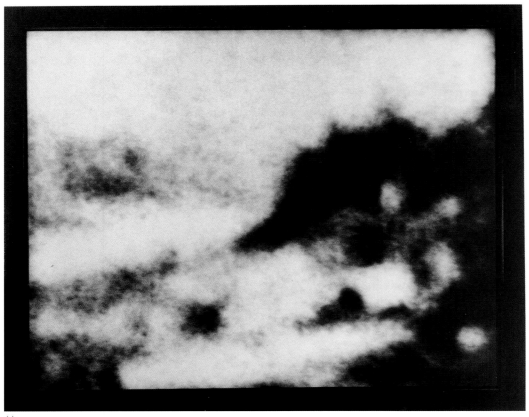

(a)

(b)

(pages 52–53) *Eighty-three Perpetual Photos*, 1982/86–89,
silver gelatin prints.

(this page) (a) *Perpetual Photo (No. 126B)* 1982–86, silver
gelatin print, 43 x 53 inches (b) *Perpetual Photo (No. 4)*,
1983–85, silver gelatin print, 8¾ x 8 inches.

PERFECT
VEHICLES

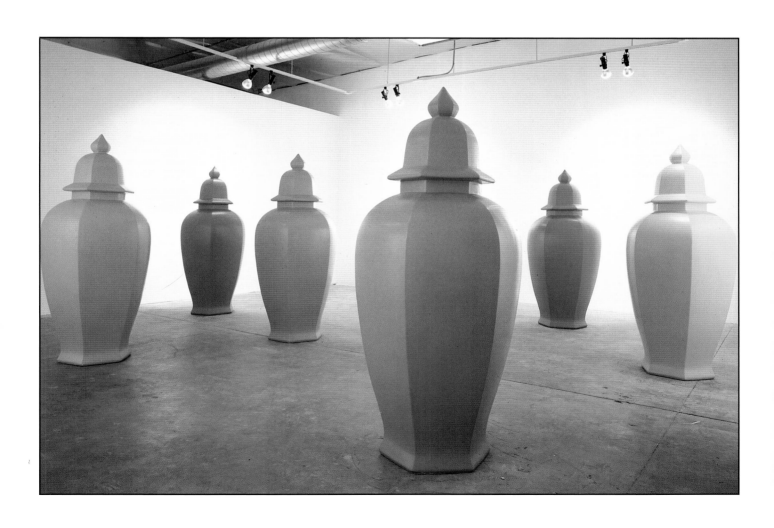

Perfect Vehicles
series begun in 1985

The *Perfect Vehicles* are
cast in solid Hydrocal from
rubber molds and painted
all over with many coats
and colors of paint. They
are grouped into small
collections, each unique.

Larger *Perfect Vehicles* are
cast from glass-fiber-rein-
forced concrete and are
also covered with many coats
of paint. Each of the larger
Perfect Vehicles is unique
in color.

(1)

(2)

(1) Studio production of *Perfect Vehicles*,
1993, enamel on solid-cast Hydrocal.
Photo: Eric Baum (2) Pattern for large *Perfect
Vehicle*, 1988, fiberglass and polyester resin.
Photo: Eric Baum.

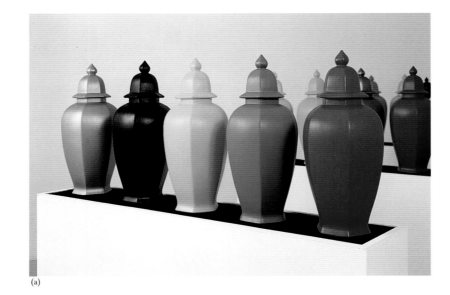

(a)

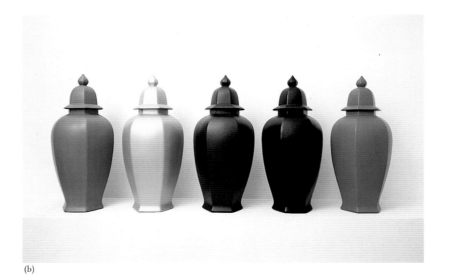

(b)

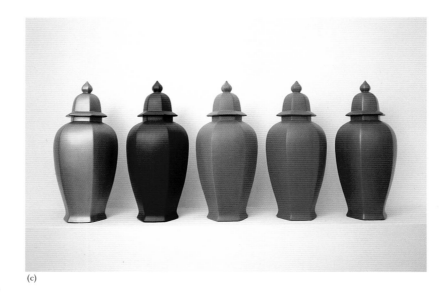

(c)

(page 55) *Perfect Vehicles*, 1988–89, Moor Glo on glass-fiber-
reinforced concrete. Installation site: Richard Kuhlenschmidt
Gallery, Los Angeles, 1986. Photo: James Franklin.

(this page) (a) *Five Perfect Vehicles,* 1985–87, enamel on
solid-cast Hydrocal. Installation site: Galerie Yvon Lambert,
Paris, 1987. Photo: Courtesy of Galerie Yvon Lambert (b) and
(c) *Five Perfect Vehicles*, 1985–86, enamel and acrylic on
solid-cast Hydrocal. Installation site: Cash/Newhouse Gallery,
New York City, 1986.

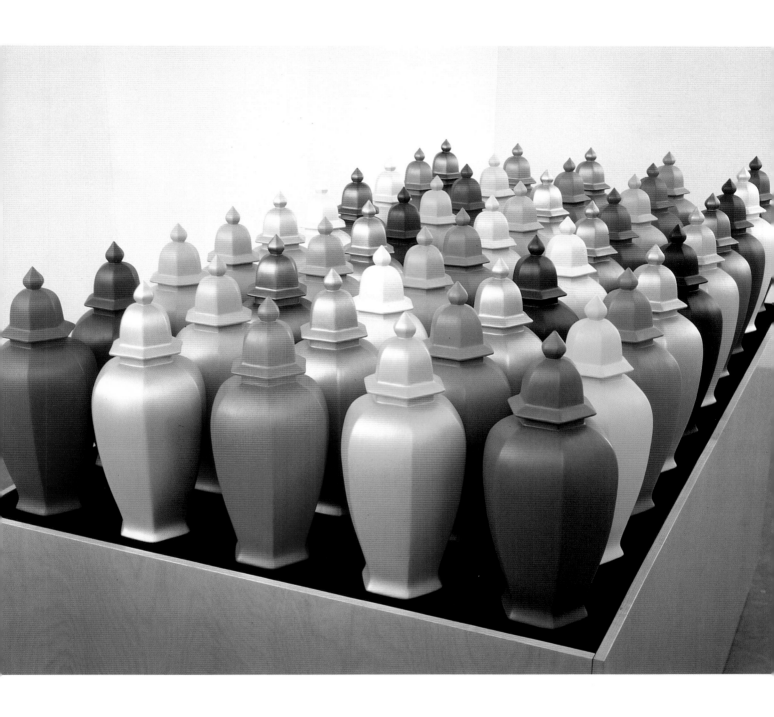

Fifty Perfect Vehicles, 1985–89, acrylic on solid-cast Hydrocal.
Installation site: Stedelijk van Abbemuseum, Eindhoven,
Holland, 1989.

(pages 43–44) *Perfect Vehicles,* 1989–90, Moor Glo on
glass- fiber-reinforced concrete. Installation site: Rooseum,
Mälmo, Sweden, 1990. Photo: courtesy of Rooseum.

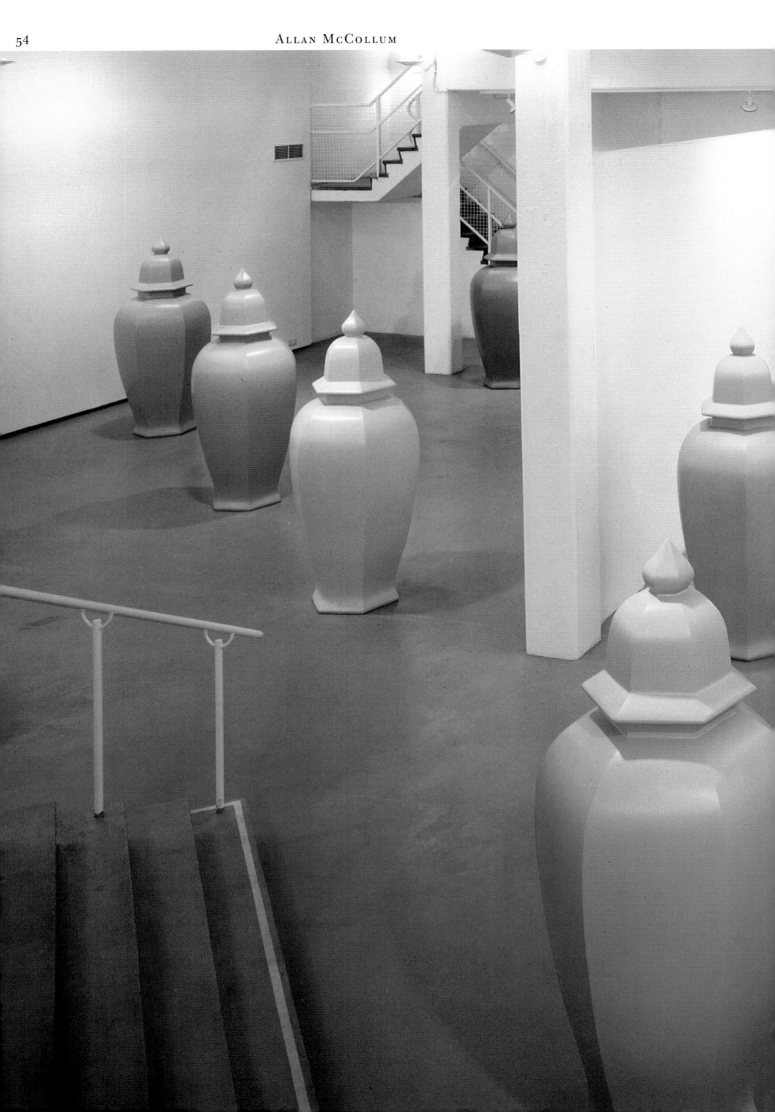

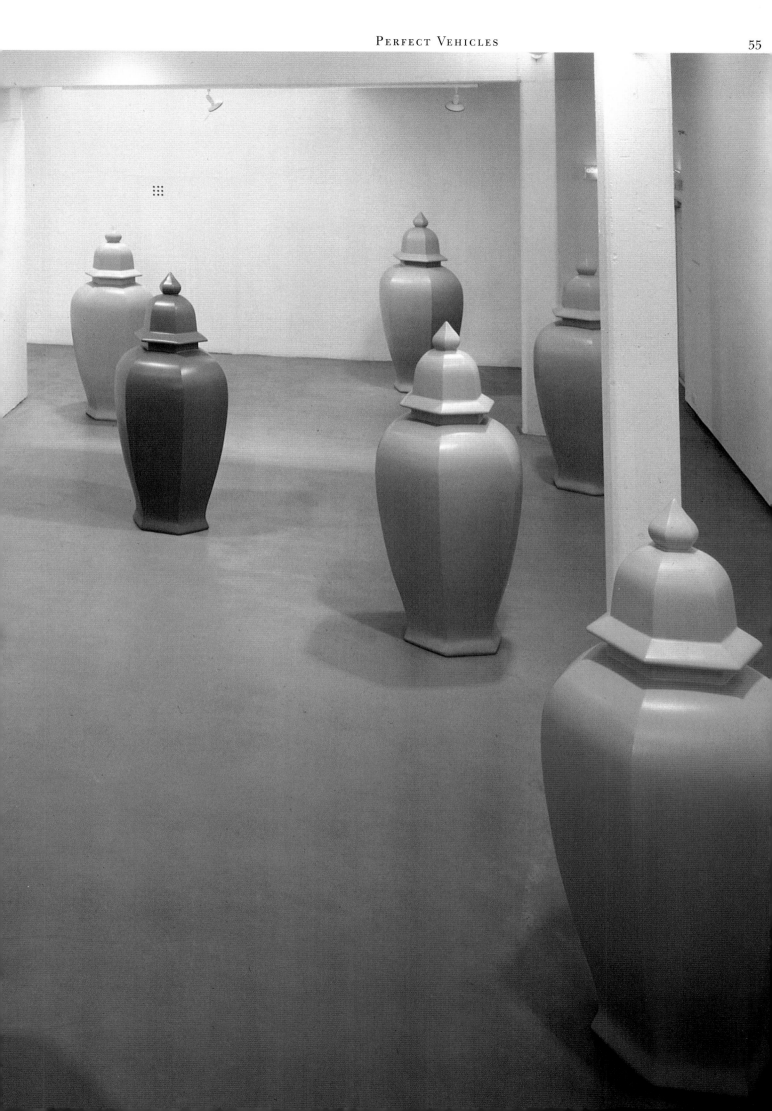

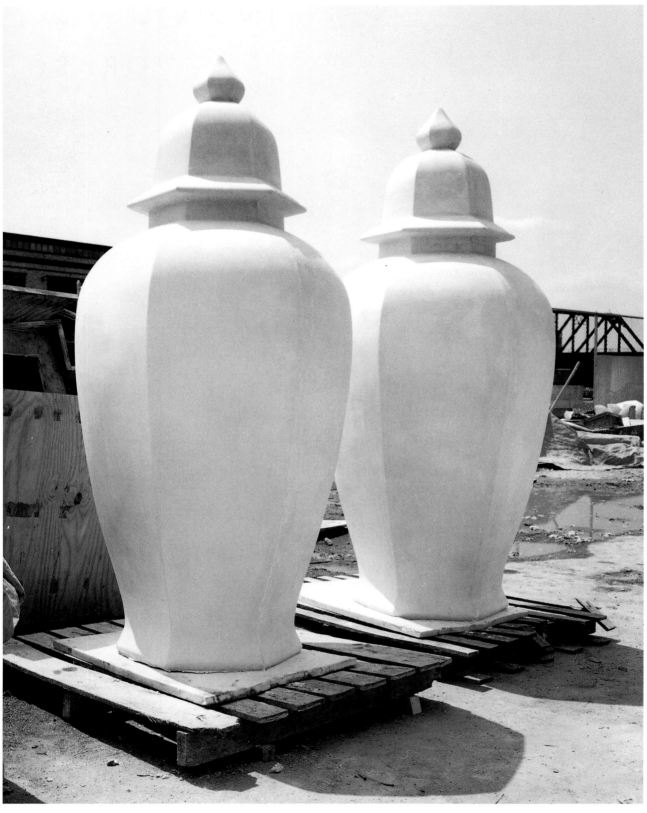

Perfect Vehicles (in progress), 78 x 36 inches each,
cast glass-fiber-reinforced concrete. Photo: Ivan Dalla Tana,
courtesy of Brooke Alexander Gallery, New York City.

INDIVIDUAL
WORKS

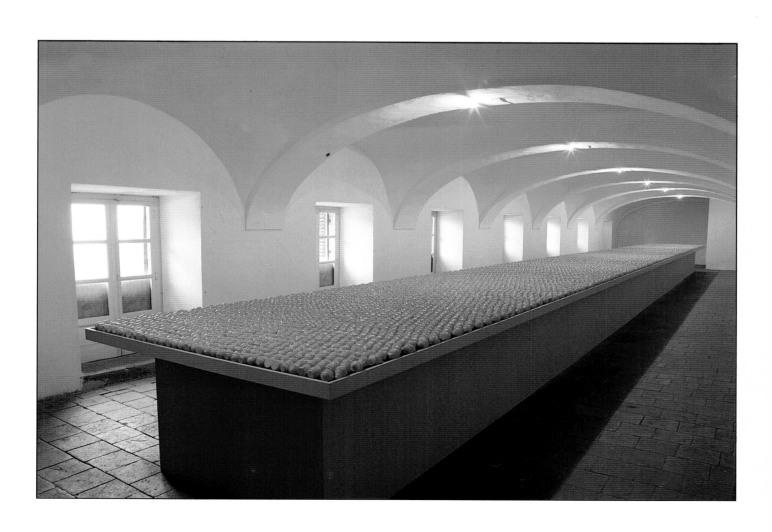

(1)

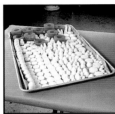

(2)

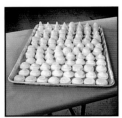

(3)

(4)

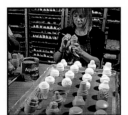

(5)

(6)

Individual Works
series begun in 1987

To produce the *Individual Works*, hundreds of small shapes are casually collected from peoples' homes, supermarkets, hardware stores, and sidewalks: bottle caps, jar lids, drawer pulls, salt shakers, flashlights, measuring spoons, cosmetics containers, yogurt cups, earrings, push buttons, candy molds, garden hose connectors, paperweights, shade pulls, Chinese teacups, cat toys, pencil sharpeners, and so on.

Rubber molds are produced from this collection of shapes. The replicas of these shapes can be cast in large quantities, thus creating a vocabulary of shapes that can be combined to produce new shapes.

A simple numerical system is used during the production process to ensure that no two *Individual Works* will ever be alike. Each *Individual Work* is hand cast in gypsum and hand painted with an enamel paint. The *Individual Works* are usually gathered into collections of over ten thousand.

(1) Original objects used for *Individual Works* (2) Molds and casts of original objects forming basic vocabulary of shapes
(3) Cast-Hydrocal prototypes for production molds (4) Polyurethane rubber production molds (5) Studio production of *Individual Works*
(6) Workbooks and cast-Hydrocal pieces for *Individual Works*.
Photo: Eric Baum.

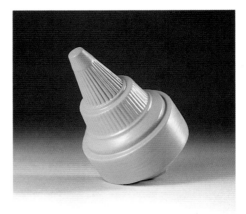

(a)

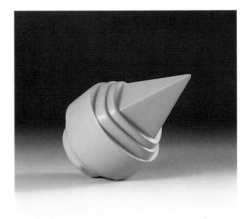

(b)

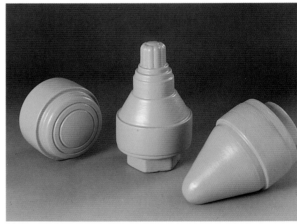

(c)

(page 61) *Over Ten Thousand Individual Works,* 1987–89, acrylic on Hydrocal. Installation site: Castello di Rivara, Turin, 1993.

(this page) (a) through (c) *Individual Works,* 1987–88, enamel on cast Hydrocal, approximately 2 x 5 inches each. Photo: Fred Scruton.

(right) *Over Ten Thousand Individual Works,* 1987–89, acrylic on Hydrocal. Installation site: Castello di Rivara, Turin, 1993.

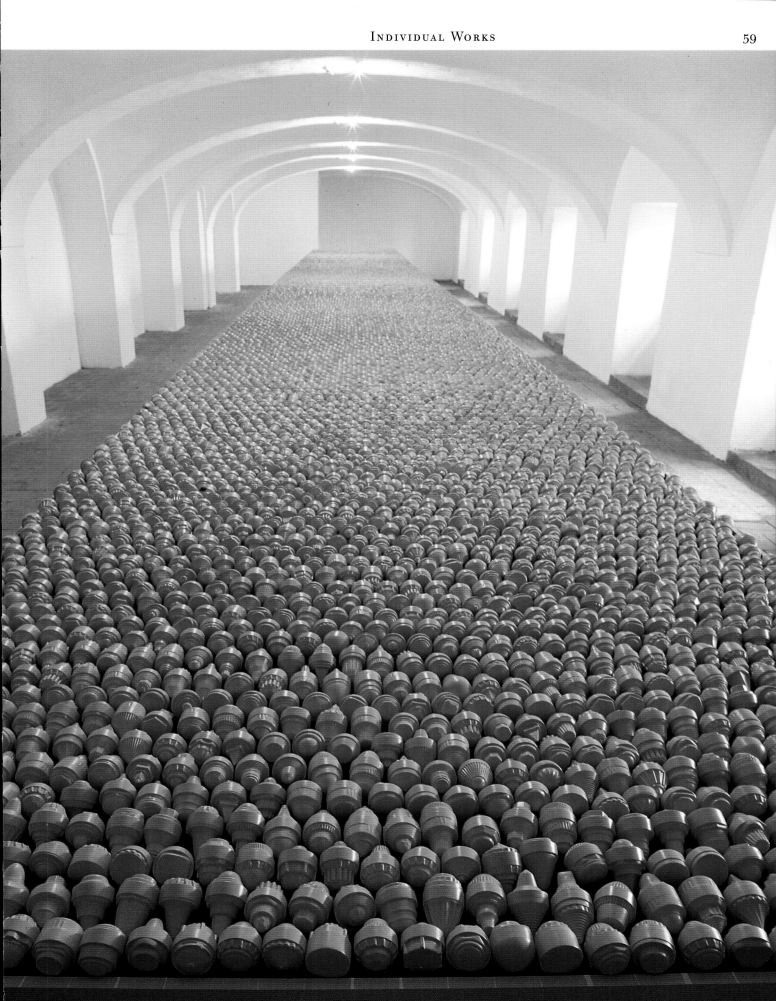

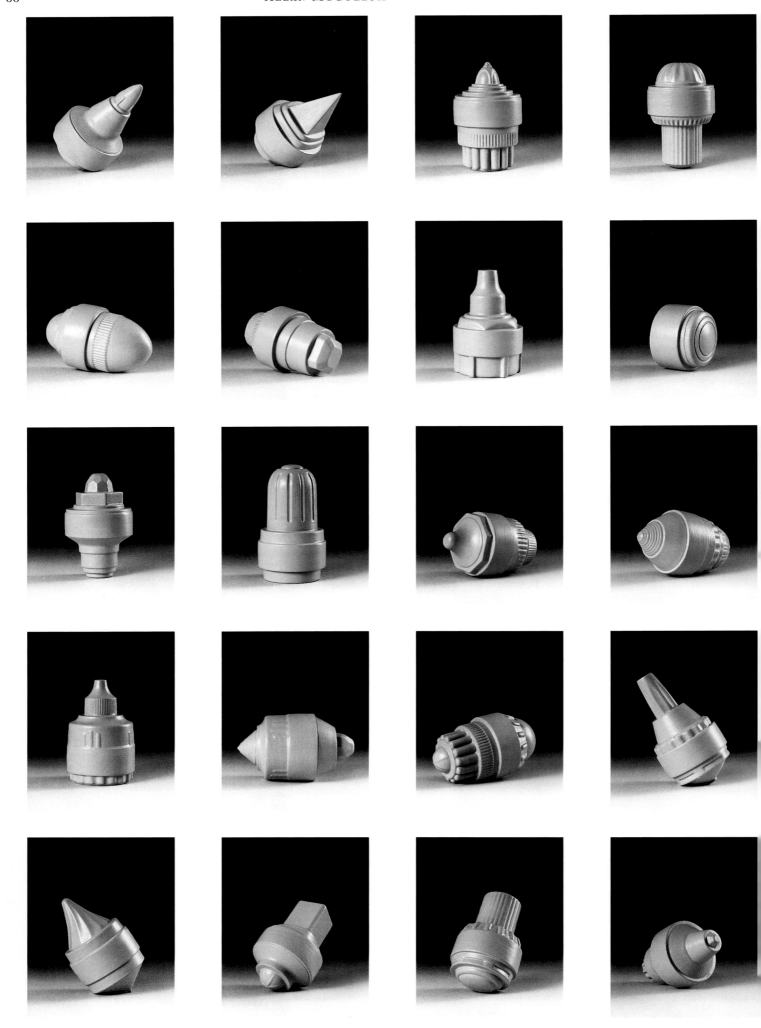

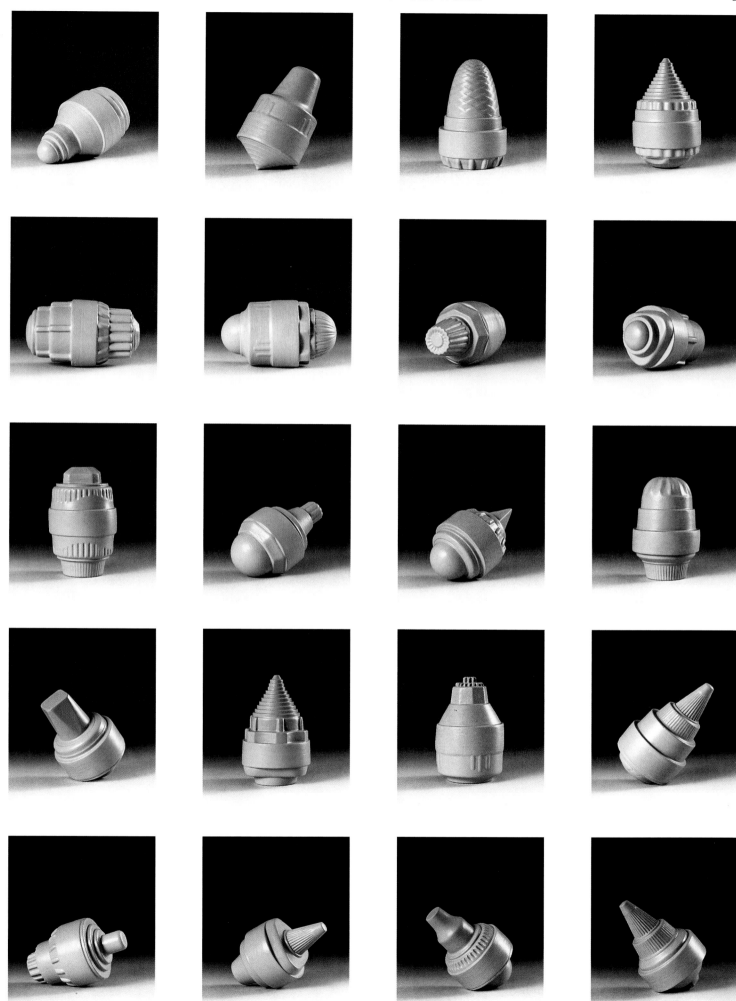

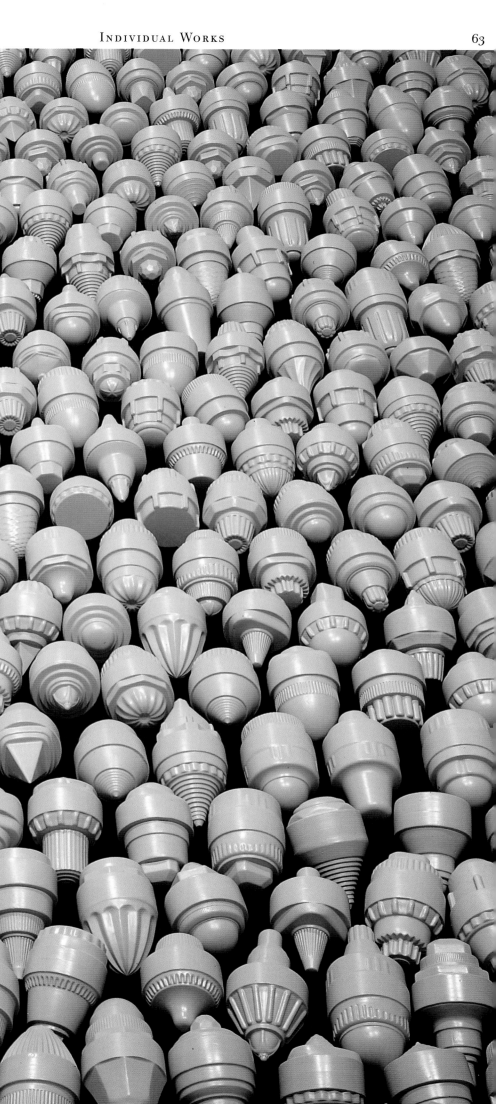

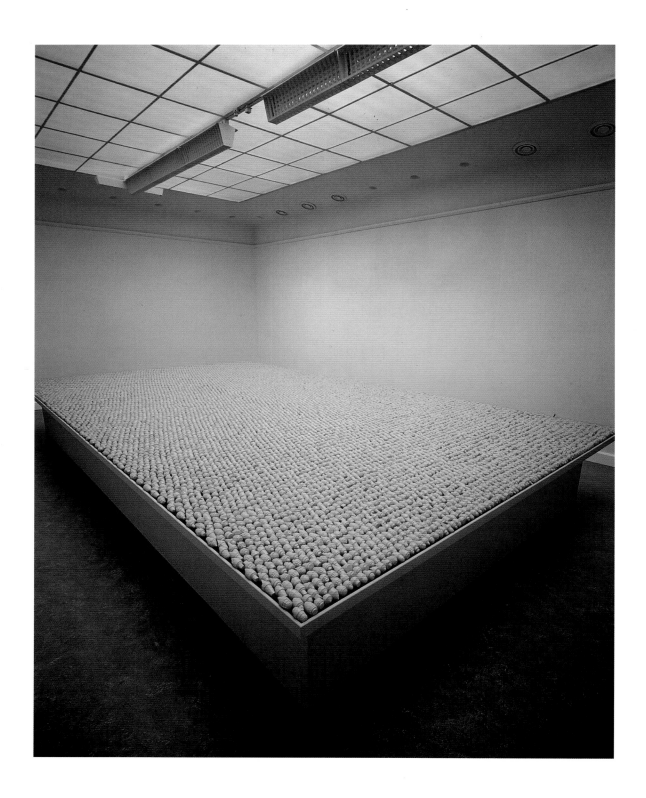

(pages 64–65) *Individual Works*, 1987–88, enamel on
Hydrocal. Photos: Fred Scruton (pages 66–67) *Over Ten
Thousand Individual Works,* 1987–88, enamel on Hydrocal.
Installation site: John Weber Gallery, New York City, 1988.
Photo: Fred Scruton (this page) *Over Ten Thousand
Individual Works,* 1987–88, enamel on Hydrocal. Installation
site: Stedelijk van Abbemuseum, Eindhoven, Holland, 1989.

DRAWINGS

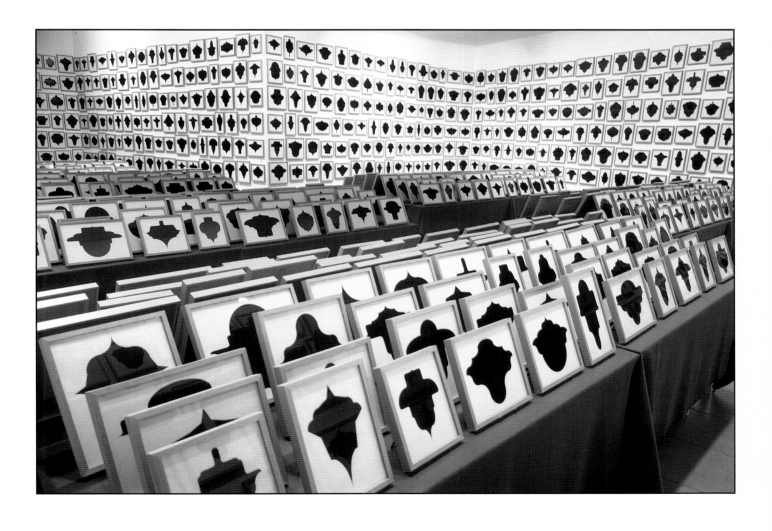

Drawings
series begun in 1988

The *Drawings* are created from variations of two basic graphic elements: ninety-degree arcs and straight lines. Combinations of these elements are cut into hundreds of different plastic templates that can be paired in thousands of different ways. The *Drawings* are produced entirely by hand, using artist's drawing pencils on museum board. The system of templates is expandable to produce billions of unique *Drawings* and a simple numerical system is used to ensure that no two *Drawings* are ever exactly alike.

Workbooks and templates for *Drawings* series. Photo: Eric Baum.

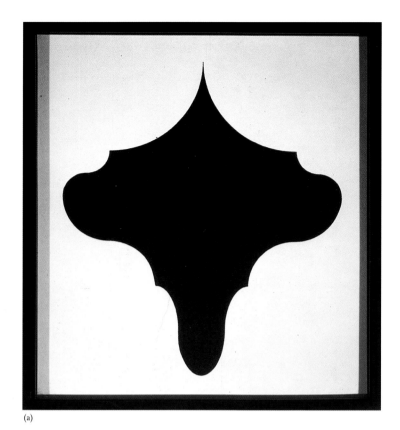

(a)

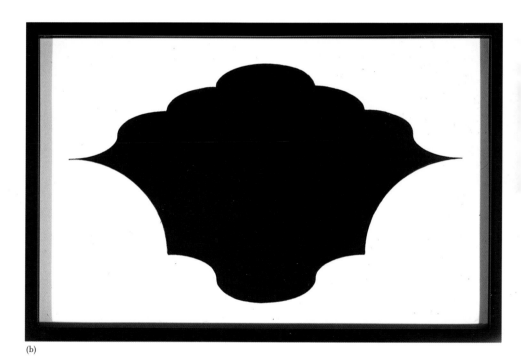

(b)

(page 69) *Drawings,* 1988–91, artist's pencil on museum board. Installation site: Lisson Gallery, London, 1991.

(this page) (a) and (b) *Drawings,* 1988–90, artist's pencil on museum board.

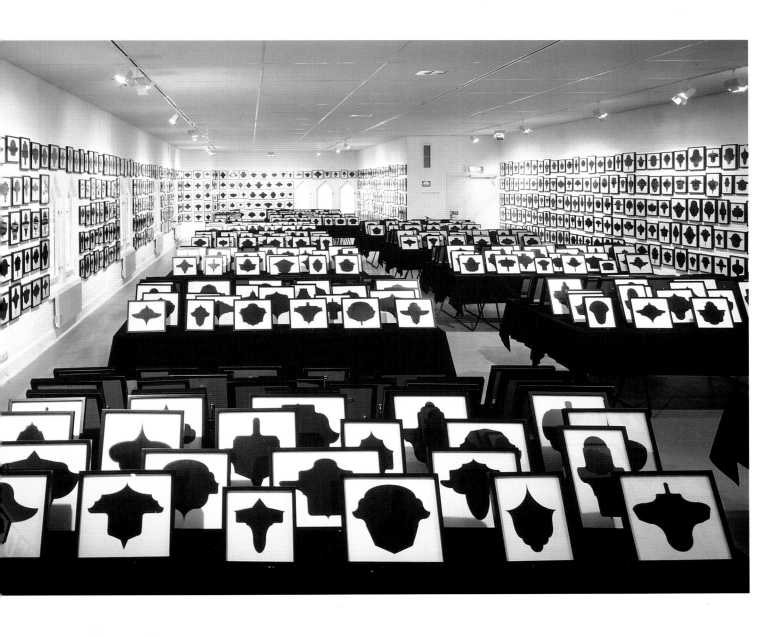

Drawings, 1988–90, artist's pencil on museum board.
Installation site: Rooseum, Mälmo, Sweden, 1990.

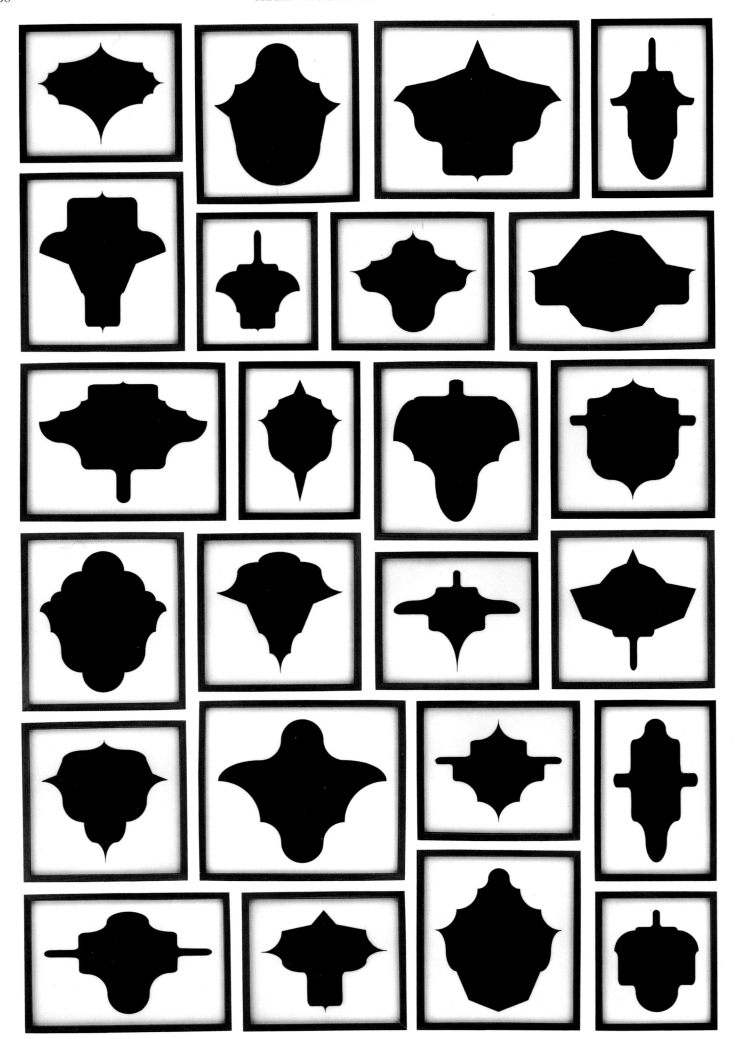

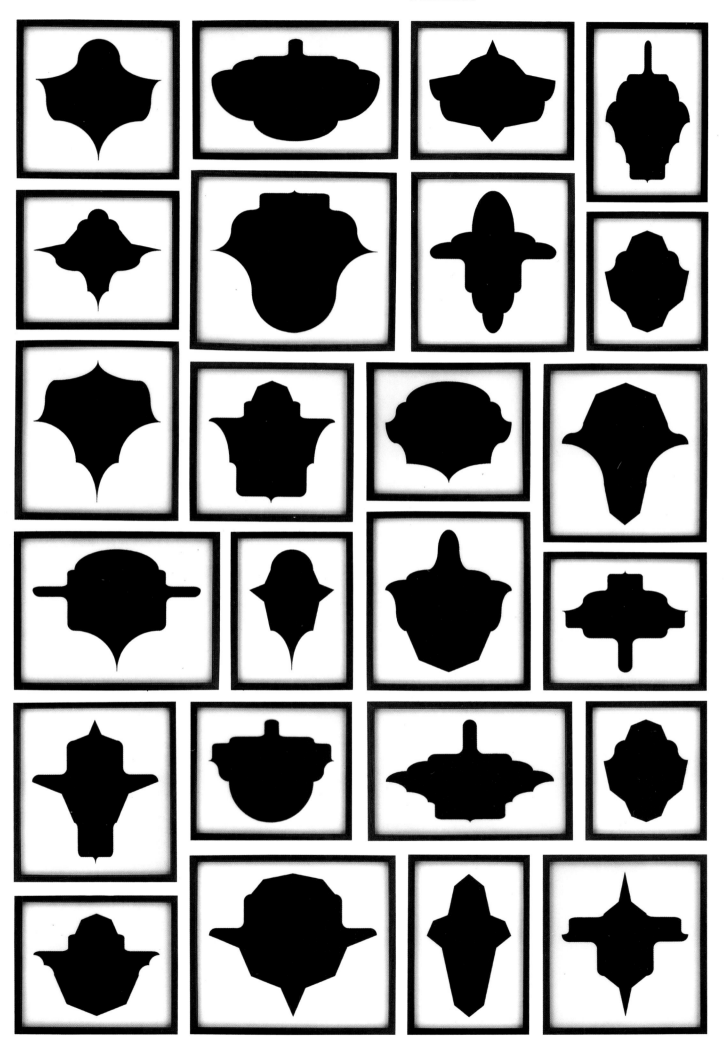

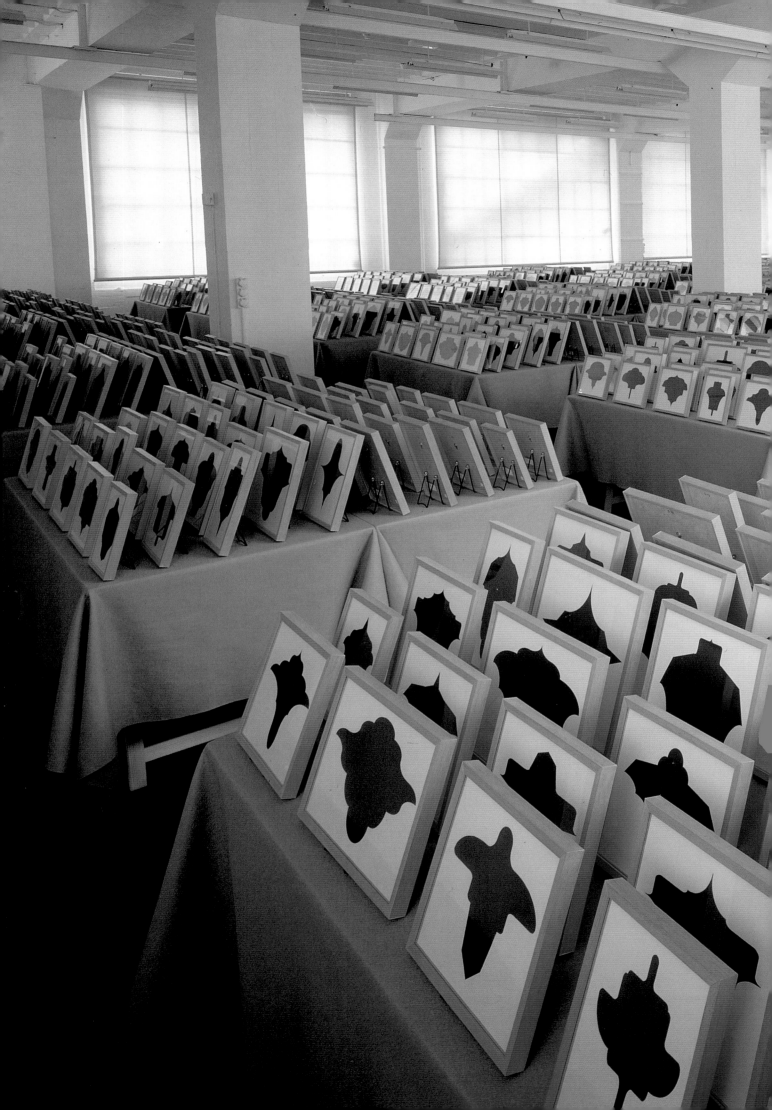

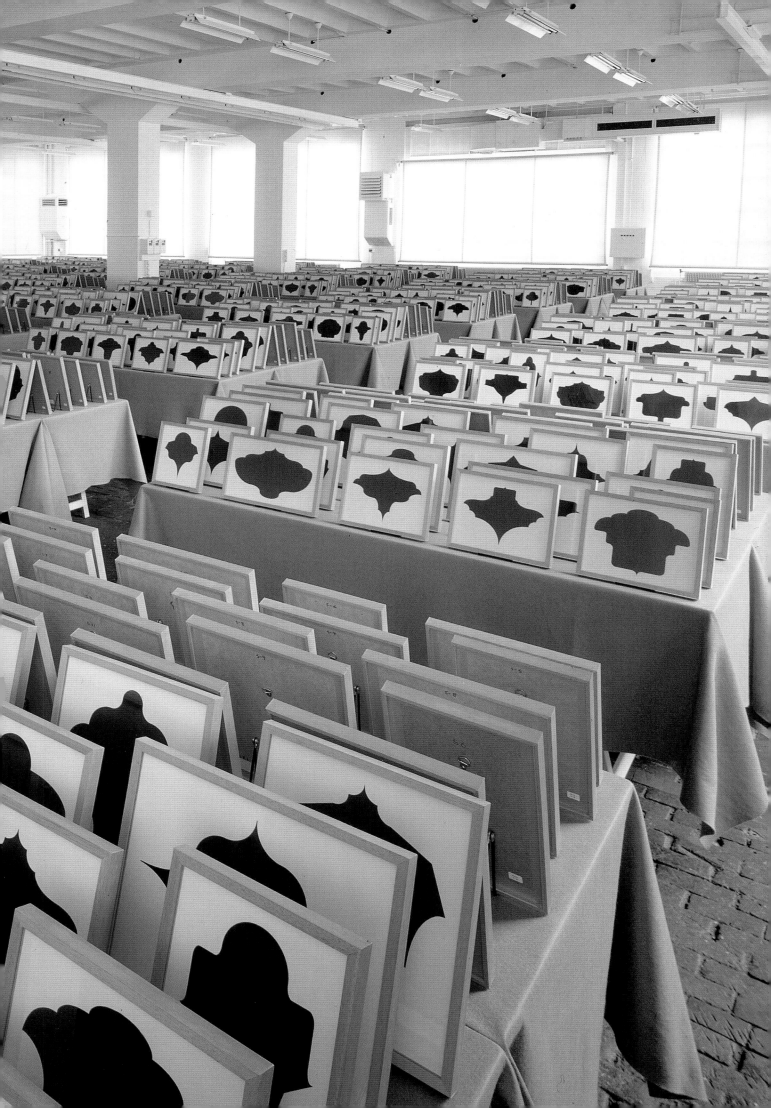

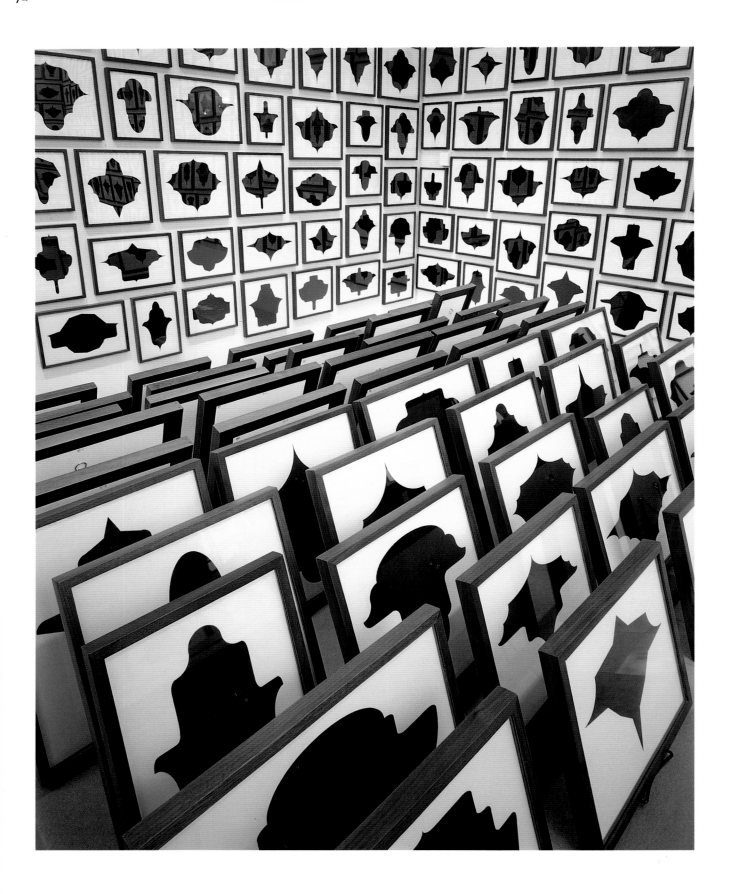

(pages 72–73) *Forty-eight Drawings,* 1988–190, artist's pencil
on museum board (pages 74–75) *Drawings,* 1988–91, artist's
pencil on museum board. Installation site: Centre d'Art
Contemporain, Geneva, 1991.

(this page) *Drawings,* 1988–92, artist's pencil on museum
board. Installation site: Museum of Modern Art, New York,
1992.Photo: Eric Baum.

THE DOG
FROM POMPEI

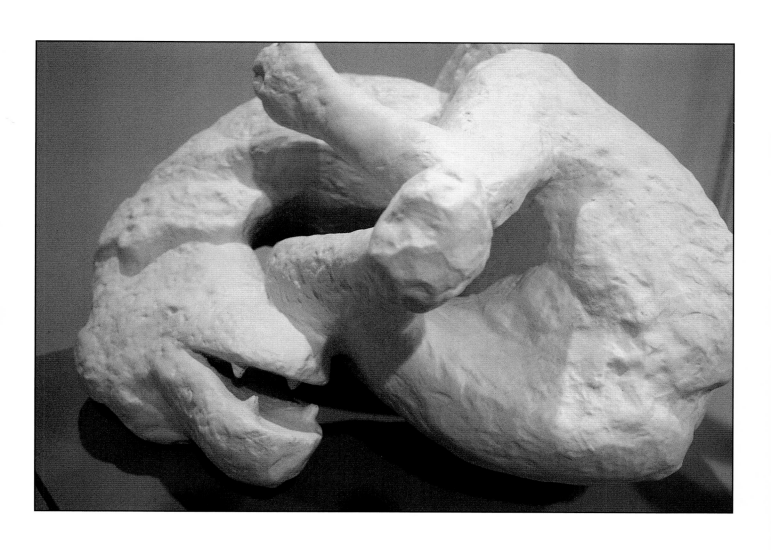

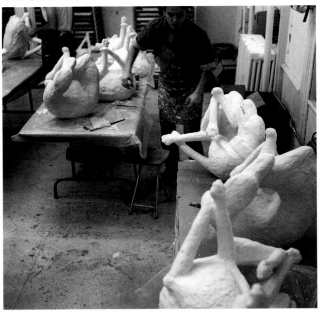

The Dog from Pompei
series begun in 1990

The Dog from Pompei casts
are taken from a mold that
was made from the famous
"chained dog" plaster cast in
the collection of the Vesuvius
Museum in Pompei, Italy.
The original dog was
smothered in volcanic ash
during the eruption of Mt.
Vesuvius in A.D. 79. Its body
left a cavity in the earth
after it deteriorated over the
centuries. This natural mold
was discovered by excavators
in 1874, and they produced
the original cast by pouring
plaster into the cavity and
excavating the resulting cast
once it had hardened. The
original natural mold was
destroyed in the process.
The Dog from Pompei casts
are produced in polymer-
enhanced Hydrocal.

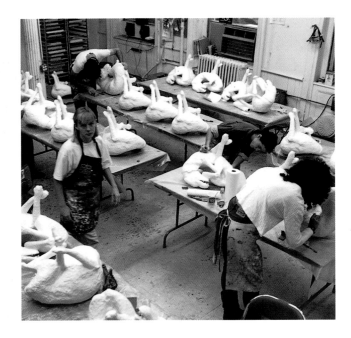

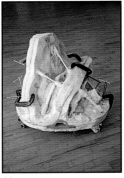

(1)

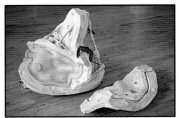

(2)

(1) and (2)Production mold for *The Dog from
Pompei.* Photos: Wendy Waxman.

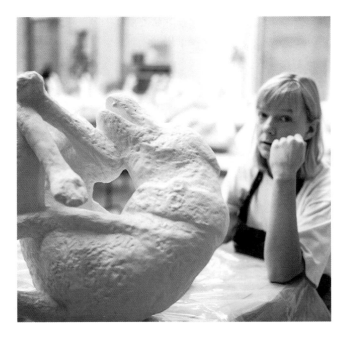

(page 77) *The Dog from Pompei*, 1991, polymer-modified
Hydrocal, 21 x 21 inches each. Installation site: John Weber
Gallery, New York City, 1992.

(right) *The Dog from Pompei*, work in progress in the artist's
studio in New York City.

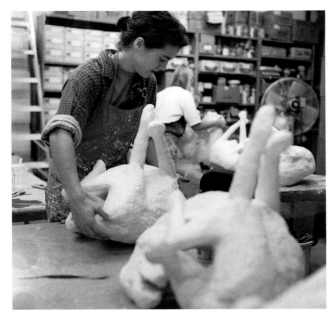

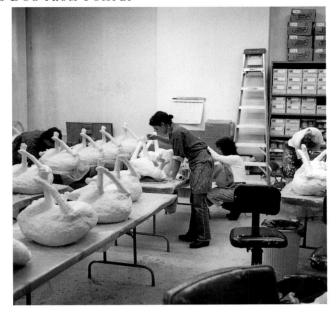

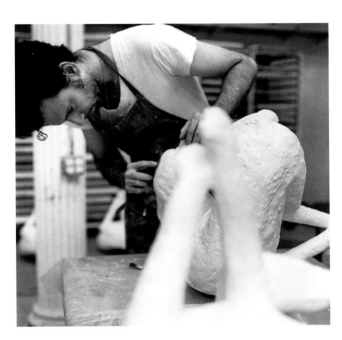

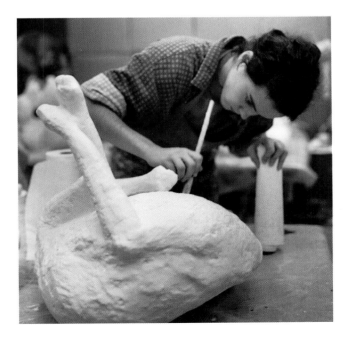

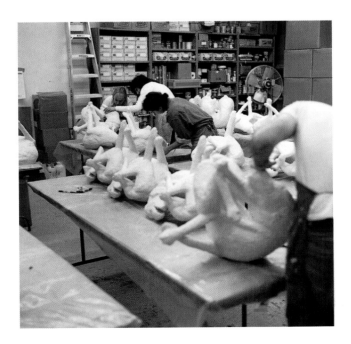

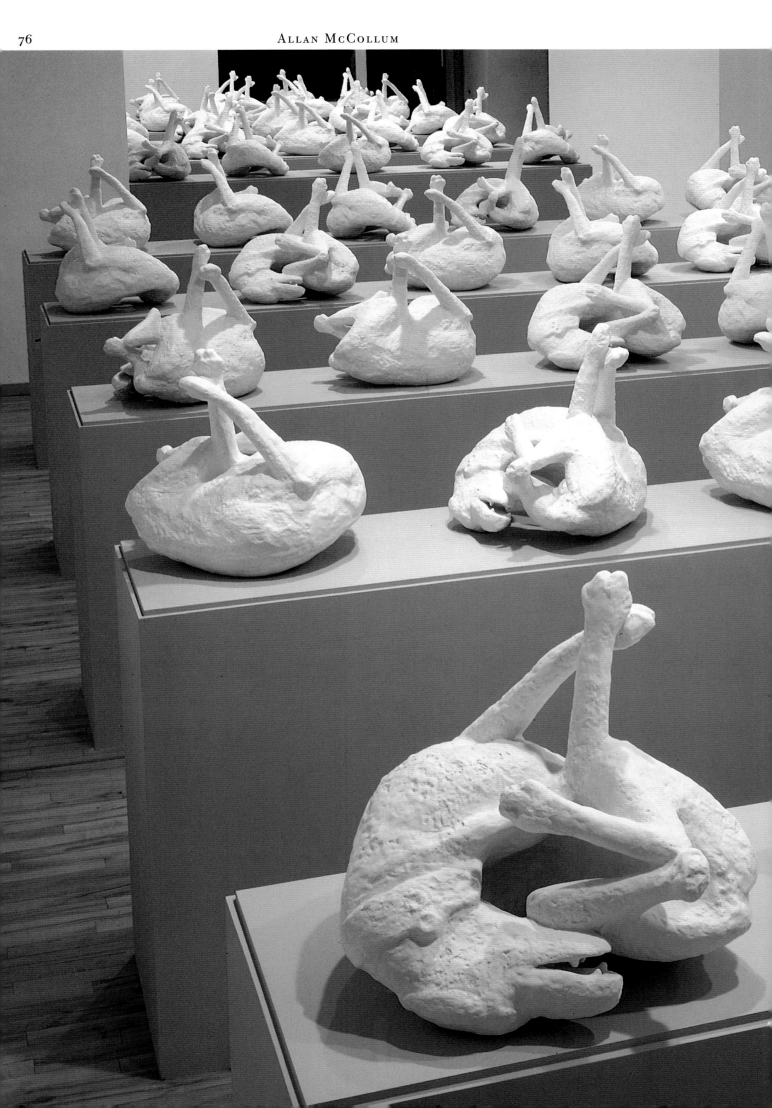

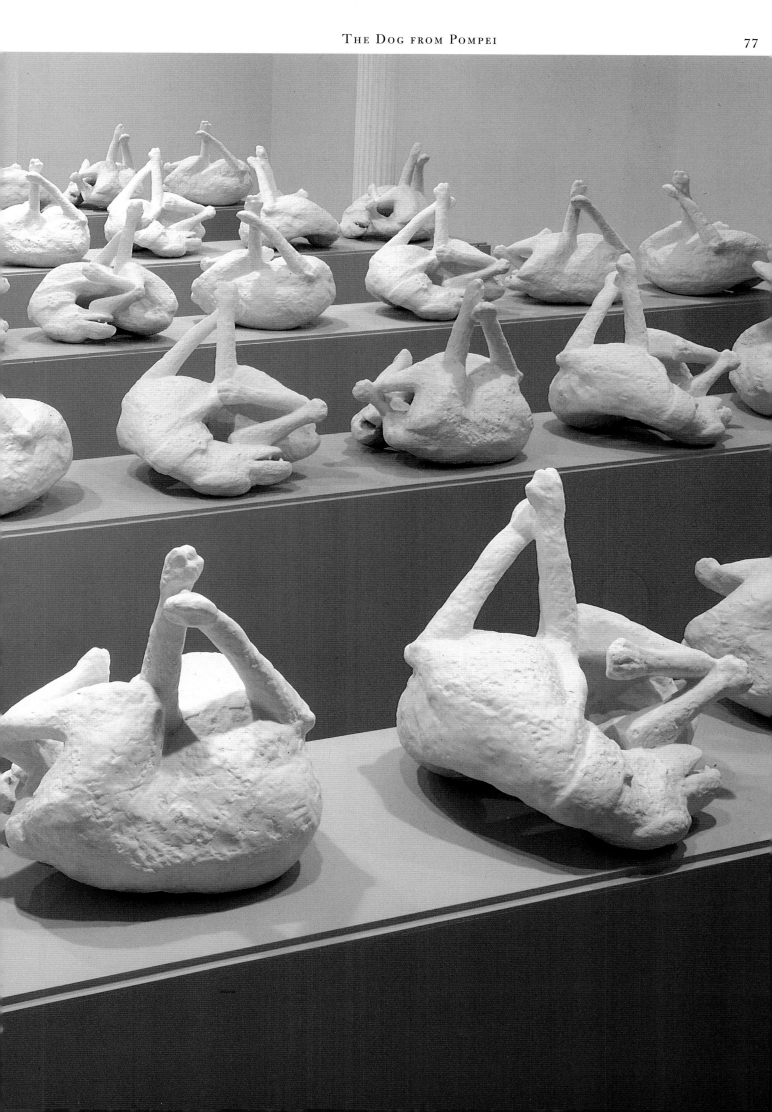

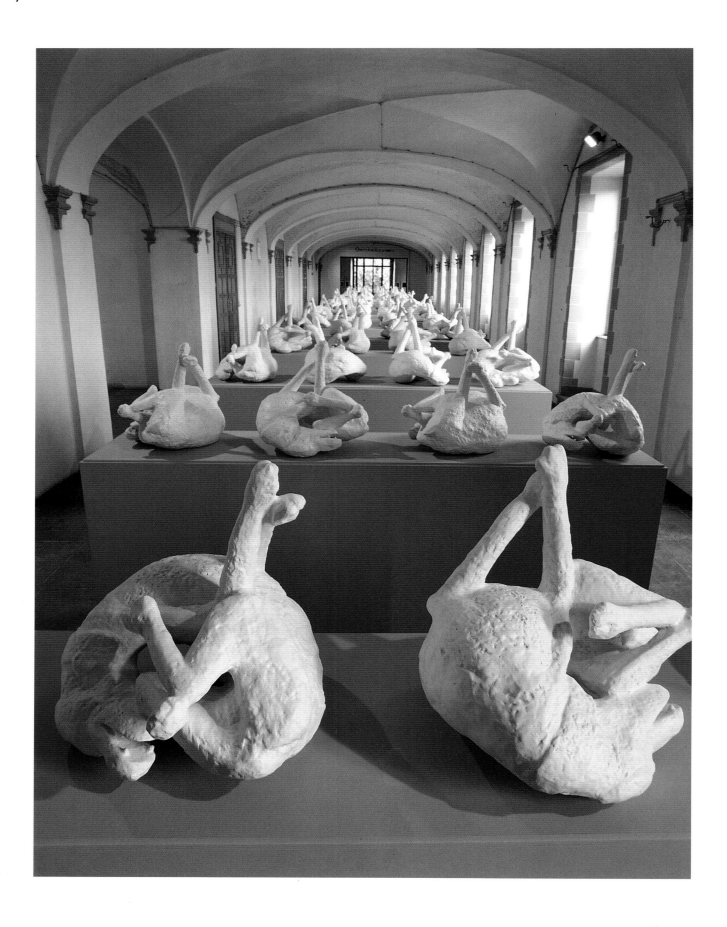

(pages 80–81) *The Dog from Pompei*, 1991, polymer-modified
Hydrocal, 20 x 21 x 21 inches each. Installation site: John
Weber Gallery, New York City, 1992.

(this page) *The Dog from Pompei*, 1991, polymer-modified
Hydrocal, 20 x 21 x 21 inches each. Installation site: Castello di
Rivara, Turin, 1993.

LOST OBJECTS

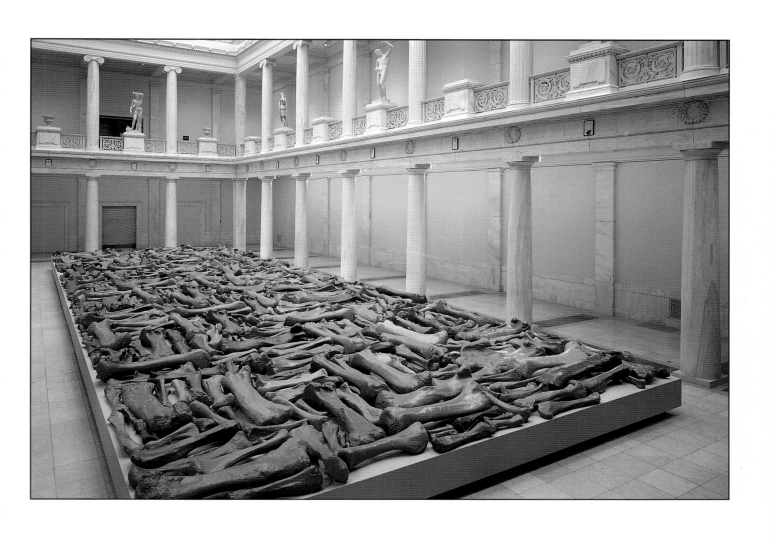

Lost Objects
series begun in 1991

The *Lost Objects* are cast in glass-fiber-
reinforced concrete from rubber molds taken
of fossil dinosaur bones in the vertebrate
paleontology section of the Carnegie Museum
of Natural History in Pittsburgh. The casts are
painted all over with many coats of enamel
paint. Fifteen molds have been made, and the
casts have been painted in about fifty different
colors, making over 750 unique *Lost Objects* to
date. The *Lost Objects* are grouped into large,
unique collections of different sizes and colors.

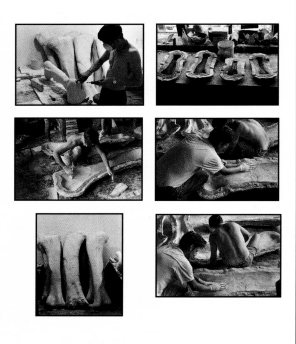

(above) *Lost Objects*, in progress at Essex Works, New York.
Photos: Nathan Lieb.

(page 83) *Lost Objects,* 1991, enamel on cast concrete,
Installation site: Carnegie Museum, Pittsburgh, 1991.

(right) *Lost Objects*, 1991, installation in progress, Carnegie
Interational 1991, Carnegie Museum of Art, Pittsburgh.
Photos: Recha Campfens.

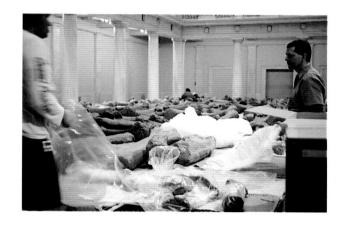

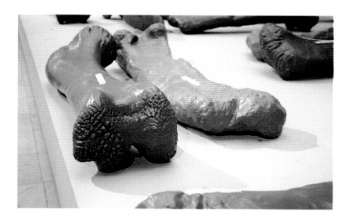

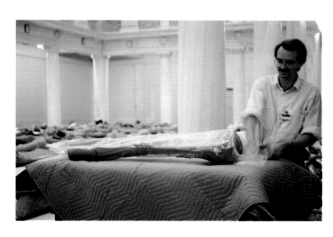

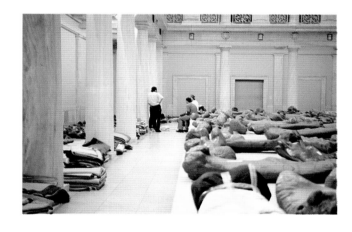

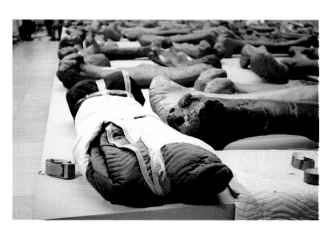

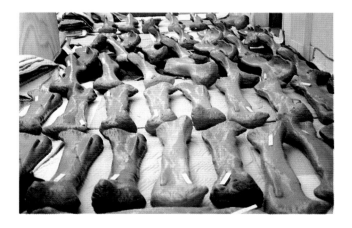

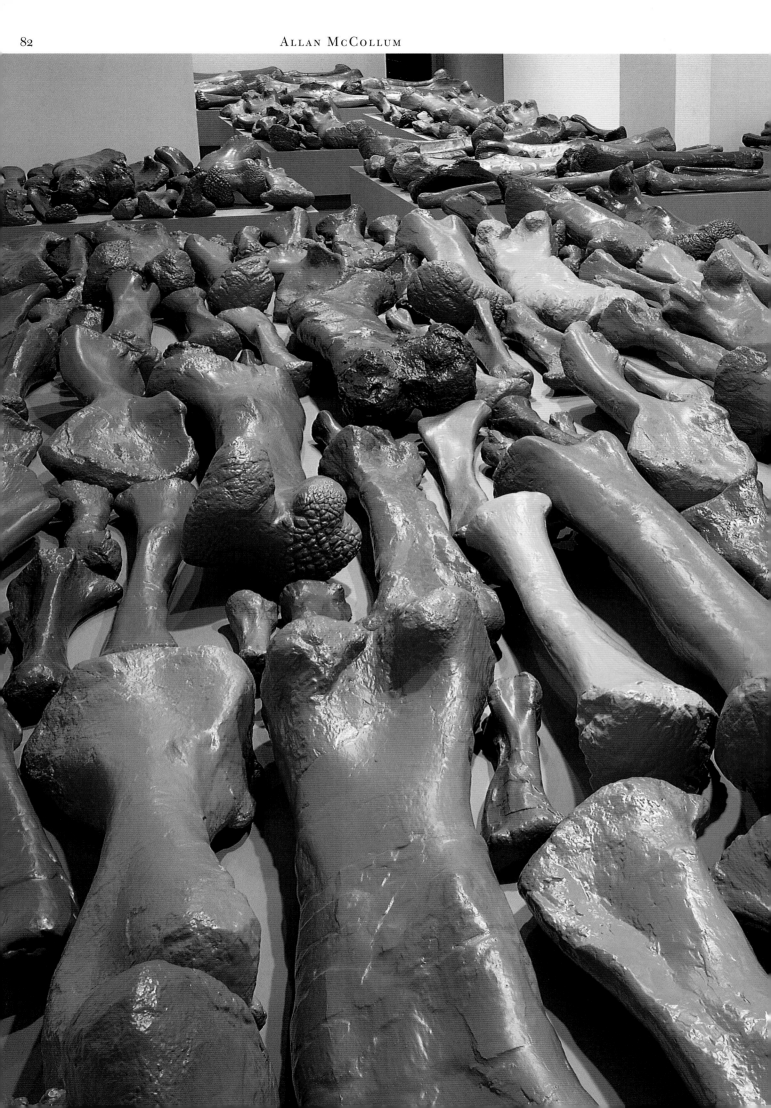

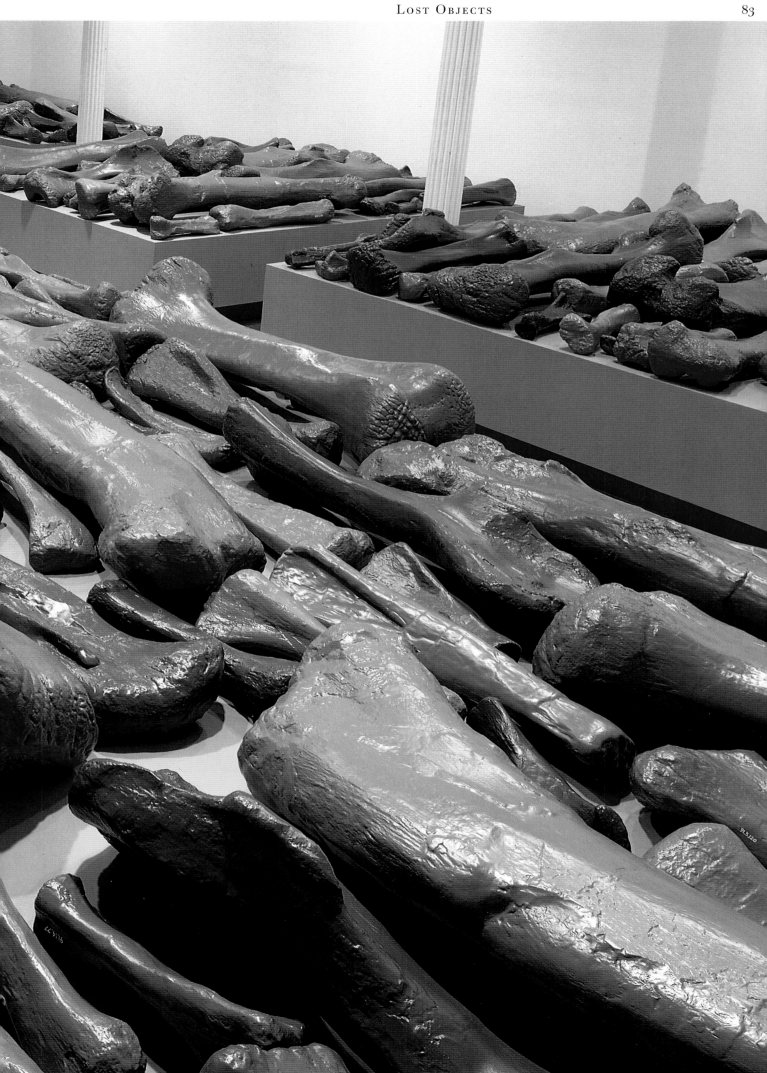

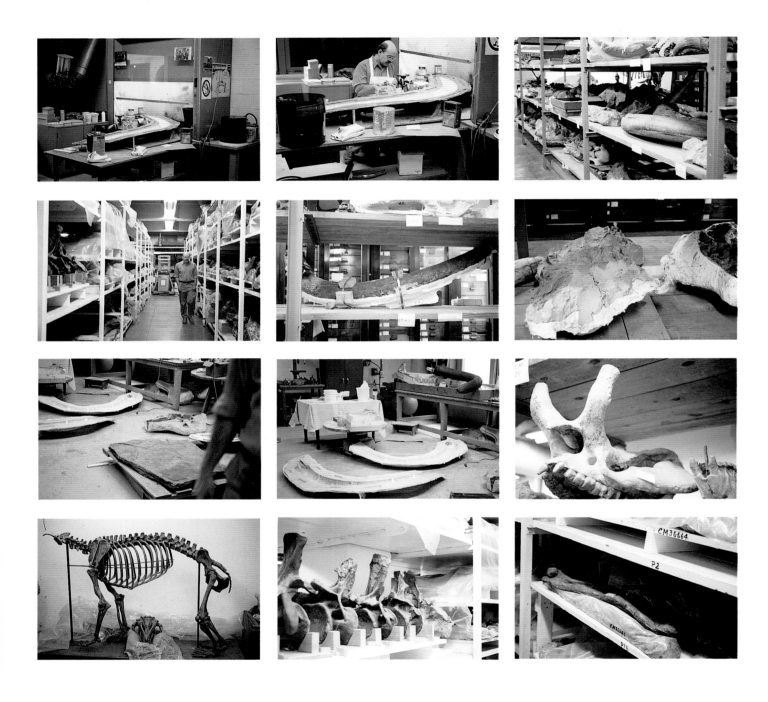

(pages 86–87) *Lost Objects*, 1991, enamel on cast concrete.
Installation site: John Weber Gallery, New York City, 1992.
Photo: Fred Scruton

(this page) twelve views of Carnegie Museum of Natural History
vertebrate paleontology Lab, bone storage, Pittsburgh. Photos: Eric
Baum.

NATURAL COPIES
FROM THE COAL MINES
OF CENTRAL UTAH

*Natural Copies from the Coal Mines
of Central Utah*
series begun in 1994

The *Natural Copies from the Coal Mines of
Central Utah* are produced by dinosaurs
walking over spongy beds of decaying
vegetation (peat); by the footprints being filled
with sand; by the accumulation of thousands
of feet of additional sediment, which
compresses the peat to help form coal and
solidifies the sand to sandstone; by removal of
the coal in mining operations, which leaves
the tracks protruding downward into the mine
from the mine roof; by the mine workers
removing the natural track casts from the roofs
with chisels, often for mine safety reasons; by
the workers taking the casts home to use as
ornaments for their front yards or as
conversation pieces in the reception areas of
local businesses; by the casts later being
donated to the local College of Eastern Utah
Prehistoric Museum, in the coal mining town
of Price, Utah; by the artist working in
cooperation with the museum to make molds
of their entire track cast collection; by these
molds being taken to New York City; by
Natural Copies being made from the molds in
polymer-reinforced Hydrocal; and, finally, by
painting the *Natural Copies* all over with many
coats of enamel paint. Forty-four molds have
been made, and the casts have been
painted in eight different colors, making over
352 unique *Natural Copies* to date. They are
grouped into unique collections of different
sizes and colors.

(left to right) Marvin Evans, preparator; Pamela Miller, curator;
Allan McCollum, artist; John Bird, moldmaker and preparator,
College of Eastern Utah Prehistoric Museum, Price, Utah.

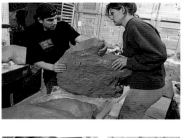 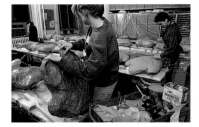

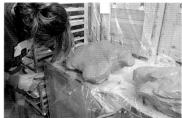 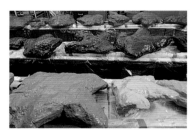

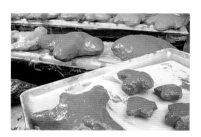

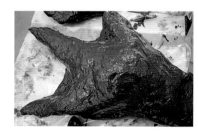 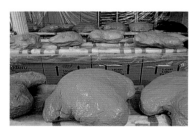

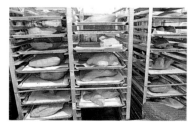

(page 89) *Natural Copies from the Coal Mines of Central Utah,*
1994–95, enamel on polymer-reinforced Hydrocal.

(this page) *Natural Copies from the Coal Mines of Central
Utah,* in progress in the artist's studio, New York City.

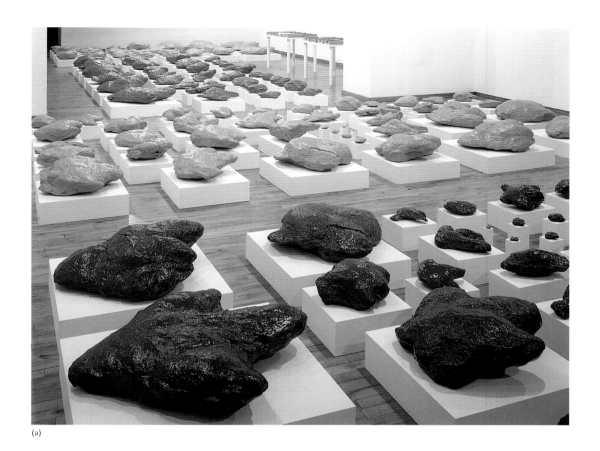

(a)

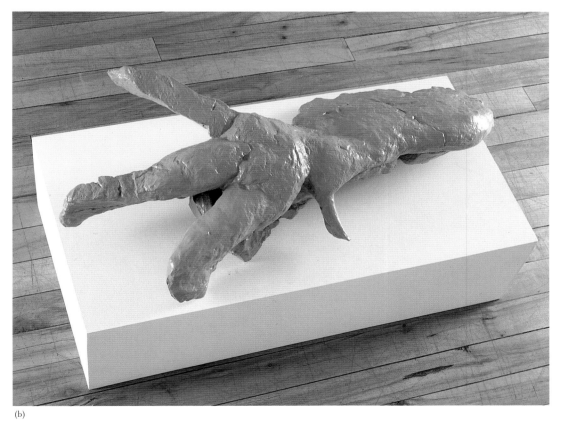

(b)

(a) and (b) *Natural Copies from the Coal Mines of Central Utah,* 1994–95, enamel on polymer-reinforced Hydrocal. Installation site: John Weber Gallery, New York City, 1995. Photo: Fred Scruton.

(pages 92–93) *Natural Copies from the Coal Mines of Central Utah,* 1994–95, in progress in the artist's studio, New York City, 1995. Photo: Eric Baum.

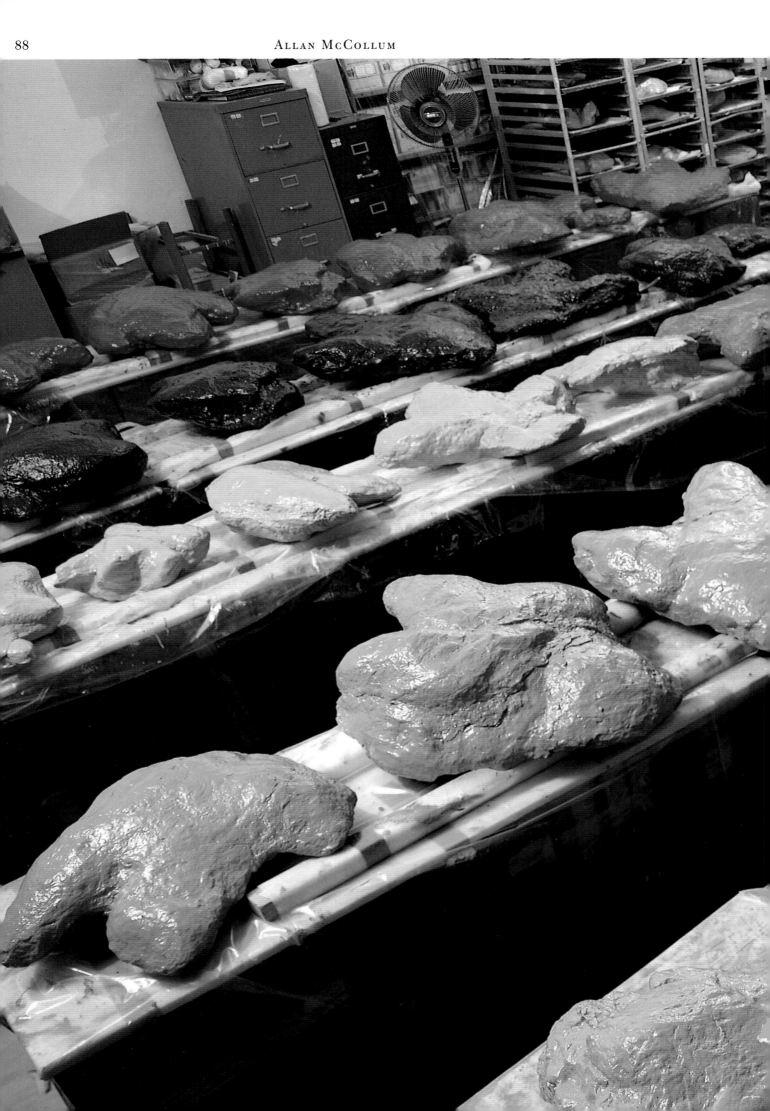

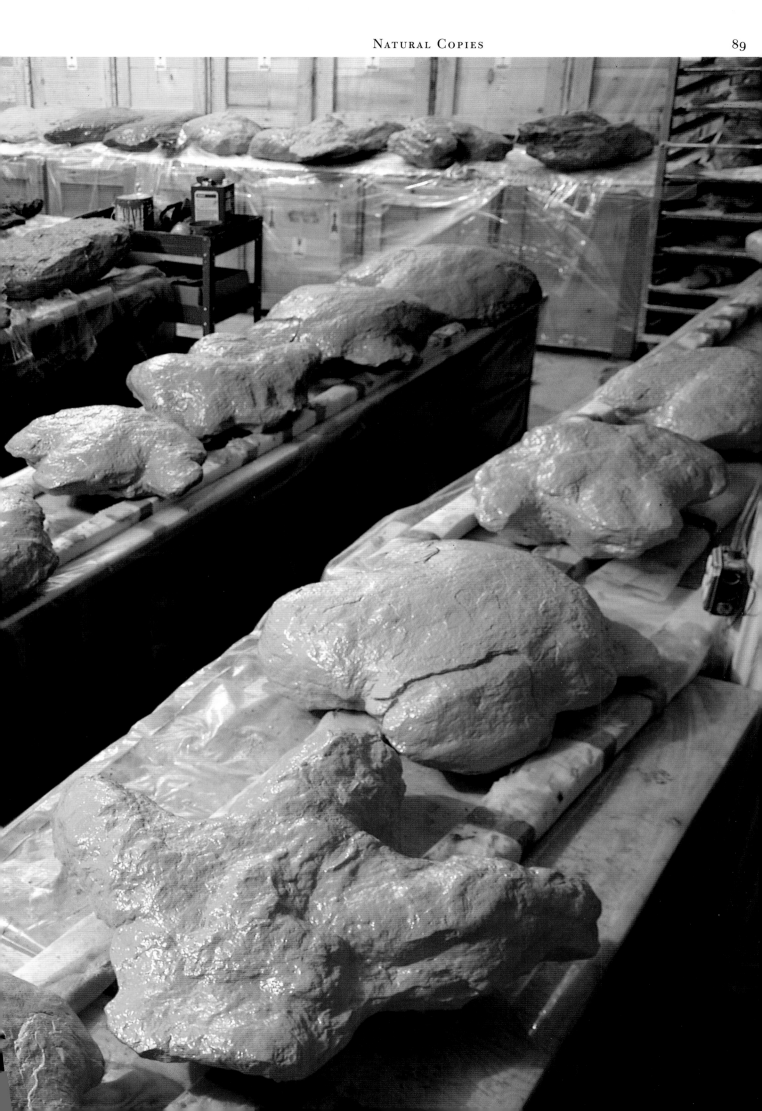

Biography

Born 1944 in Los Angeles.
Lives and works in New York City.

SOLO EXHIBITIONS

1971
Jack Glenn Gallery, Corona Del Mar, California.

1972
Jack Glenn Gallery, Corona Del Mar, California.

1973
Nicholas Wilder Gallery, Los Angeles.
Cusack Gallery, Houston.

1974
Nicholas Wilder Gallery, Los Angeles.

1975
Douglas Drake Gallery, Kansas City, Kansas.

1977
Claire S. Copley Gallery, Los Angeles.

1979
Surrogate Paintings, Julian Pretto and Company, New York.
Surrogate Paintings, Douglas Drake Gallery, Kansas City, Kansas.

1980
Surrogate Paintings, Galerie Yvon Lambert, Paris.
Surrogate Paintings, Artists Space, New York.
Surrogate Paintings, 112 Workshop, New York.

1981
Glossies, Dioptre, Geneva.
Surrogate Paintings, Hal Bromm Gallery, New York.

1982
Surrogate Paintings, Galerie Nicole Gonet, Lausanne, Switzerland.
Surrogate Paintings, Heath Gallery, Atlanta.
Allan McCollum, Ben Shahn Galleries, William Paterson College, Wayne, New Jersey. Brochure with artist's statement.

1983
Plaster Surrogates, Marian Goodman Gallery, New York.
Plaster Surrogates, Douglas Drake Gallery, Kansas City, Kansas.

1984
Plaster Surrogates, Rhona Hoffman Gallery, Chicago.
Plaster Surrogates, Richard Kuhlenschmidt Gallery, Los Angeles.
For Presentation and Display: Ideal Settings, Diane Brown Gallery, New York (with Louise Lawler).

1985
Plaster Surrogates, Lisson Gallery, London. Catalog with essay by Craig Owens.
Plaster Surrogates, Cash/Newhouse Gallery, New York.
Actual Photos, Gallery Nature Morte, New York (with Laurie Simmons).
Actual Photos, Heath Gallery, Atlanta (with Laurie Simmons).
Actual Photos, Texas Gallery, Houston (with Laurie Simmons).
Actual Photos, Rhona Hoffman Gallery, Chicago (with Laurie Simmons).
Actual Photos, Kuhlenschmidt/Simon Gallery, Los Angeles (with Laurie Simmons).

1986
Perfect Vehicles, Cash/Newhouse Gallery, New York.
Plaster Surrogates, Guttenbergstrasse 62, Stuttgart.
Investigations 1986: Allan McCollum, Institute of Contemporary Art, University of Pennsylvania, Philadelphia. Brochure with essay by Andrea Fraser.
Perfect Vehicles, Kuhlenschmidt/Simon Gallery, Los Angeles.
Perpetual Photos, Diane Brown Gallery, New York.

1986–87
Perfect Vehicles, Rhona Hoffman Gallery, Chicago.

1987
Perfect Vehicles, Lisson Gallery, London.
Allan McCollum, Julian Pretto Gallery, New York.
Perfect Vehicles, Diane Brown Gallery, New York.

1988
Allan McCollum, Portikus, Frankfurt. Catalog with essays by Andrea Fraser and Ulrich Wilmes, in German and English.
Individual Works, John Weber Gallery, New York. Catalog with essay by Andrea Fraser.
Perfect Vehicles, Galerie Yvon Lambert, Paris.
Plaster Surrogates, Annina Nosei Gallery, New York.
Glossies, Julian Pretto Gallery, New York.
Individual Works, Musée d'Art Contemporain, Nîmes, France. Catalog with essay by Andrea Fraser, in French.
Perfect Vehicles, 1988, Brooke Alexander, New York.
 Allan McCollum and Louise Lawler, Le Consortium, Centre d'Art Contemporain, Dijon.
Perfect Vehicles, The John and Mable Ringling Museum of Art, Sarasota, Florida. Catalog with essay by Joseph Jacobs.
Allan McCollum, Stiching de Appel, Amsterdam. Catalog with essays by Andrea Fraser and Ulrich Wilmes, in German and English.

1989
Individual Works, Perpetual Photos, Kunstverein fur die Rheinlande und Westfalen, Düsseldorf. Catalog with essays by Andrea Fraser and Ulrich Wilmes, in German and English.
Perfect Vehicles, Studio Trisorio, Naples.
Perfect Vehicles, Rhona Hoffman Gallery, Chicago.
Actual Photos, Galerie Urbi et Orbi, Paris (with Laurie Simmons).
Perpetual Photos, John Weber Gallery, New York.
Plaster Surrogates, Galeria 57, Madrid.
Perfect Vehicles, Richard Kuhlenschmidt Gallery, Los Angeles.
Surrogate Paintings, Julian Pretto Gallery, New York.

1989–90
Allan McCollum, Stedelijk van Abbemuseum, Eindhoven, Holland. Catalog with essays by Anne Rorimer, Lynne Cooke, and Selma Klein-Essink, in Dutch and English.

1990
Allan McCollum, Serpentine Gallery, London. Catalog with essays by Anne Rorimer, Lynne Cooke, and Selma Klein-Essink.
Allan McCollum, IVAM Centre del Carme, Valencia, Spain. Catalog with essays by Anne Rorimer, Lynne Cooke, and Selma Klein-Essink, in Spanish.
Allan McCollum, Rooseum, Mälmo, Sweden. Catalog with essays by Lars Nittve, Anne Rorimer, Lynne Cooke, and Selma Klein-Essink, in Swedish and English.
Plaster Surrogates, Galerie Yvon Lambert, Paris.
Perfect Vehicles, Galerie Fahnemann, Berlin.
Allan McCollum, Julian Pretto Gallery, New York.
Drawings, John Weber Gallery, New York.
Perpetual Photos, The Denver Art Museum.
Perpetual Photos, Richard Kuhlenschmidt Gallery, Los Angeles.

1991
More Drawings, Lisson Gallery, London.
May I Help You? American Fine Arts Company, New York (with Andrea Fraser).
Plaster Surrogates, Galerie Franck and Schulte, Berlin.

1992
Lost Objects, John Weber Gallery, New York.
The Dog from Pompei, Galeria Weber, Alexander y Cobo, Madrid.
The Dog from Pompei, John Weber Gallery, New York.

1993
Drawings, Centre d'Art Contemporain, Geneva. Catalog with essay by Catherine Quéloz, in French and German.
Allan McCollum, Castello di Rivara, Turin.
Perpetual Photos, Modulo Centro Difusor de Arte, Lisbon.
Plaster Surrogates, Kohji Ogura Gallery, Nagoya, Japan.
Drawings, Galerie Franck and Schulte, Berlin.
The Dog from Pompei, Studio Trisorio, Naples.
240 Plaster Surrogates, Shiraishi Contemporary Art Incorporated, Tokyo.

1994
Drawings, Museum Haus Esters, Krefeld, Germany. Catalog with essay by Catherine Quéloz, in French and German.
Drawings, S. L. Simpson Gallery, Toronto.

1995
Natural Copies from the Coal Mines of Central Utah, John Weber Gallery, New York.
Natural Copies from the Coal Mines of Central Utah, Gallery X, Hufkens, Brussels.
Allan McCollum: Natural Copies, Sprengel Museum, Hanover. Catalog with essay by Dietmar Elgar, in German and English.

SELECTED GROUP EXHIBITIONS

1969
Los Angeles Annual Art Exhibition, The Municipal Art Gallery, Los Angeles. Catalog.
Mount San Antonio College Second Biennial Exhibition of Painting and Drawing, Mount San Antonio College Art Galleries, Walnut, California.

1970
Venice, California/70, California State College Art Gallery, Los Angeles. Curated by Josine Starrels.
Eighth Annual Southern California Exhibition, Long Beach Museum of Art, California. Catalog.

1971
Twenty-Four Young Los Angeles Artists, Los Angeles County Museum of Art. Curated by Maurice Tuchman and Jane Livingston.
New Painting in Los Angeles, Newport Harbor Art Museum, Balboa, California. Curated by Tom Garver. Catalog with essay by Cara Montgomery.
Off the Stretcher, Oakland Museum, California. Catalog with essay by George W. Neubert.
After-Quake, The Friends of Contemporary Art, Denver. Curated by Leroy Butler.

1972
Color-Field Painting to Post-Color-Field Abstraction: Art for the Seventies, Nelson Art Gallery, Kansas City, Missouri.
Fifteen Los Angeles Artists, Pasadena Art Museum, California. Curated by Barbara Haskell. Catalog.
Los Angeles '72, Sidney Janis Gallery, New York. Catalog.
Arnoldi/Cooper/McCollum/Wudl, Art Gallery, California State University, Fullerton. Curated by Dextra Frankl.
Art of the Seventies, Seattle Art Museum. Curated by Robert Dootson. Catalog.

1973
Twelve Statements beyond the Sixties, The Detroit Institute of Arts. Curated by Frank Kolbert. Catalog.

1974
Contemporary American Painting and Sculpture, Krannert Art Museum, Champaign, Illinois. Catalog with essays by James R. Shipley and Alan S. Weller.
Fifteen Abstract Artists, Los Angeles, Santa Barbara Museum of Art, California. Catalog with essay by Ronald Kuchta and Michael Walls.
Painting in America: Yesterday and Tomorrow, The Decorative Arts Center, New York. Curated by Dave Hickey.

1975
Biennial Exhibition, Whitney Museum of American Art, New York. Catalog with foreword by Tom Armstrong.
Eight Artists from Los Angeles, Emanuel Walter Gallery, San Francisco. Curated by Phil Linhares. Brochure.
Drawings and Works on Paper, Dootson Calderhead Gallery, Seattle.

1977
Unstretched Surfaces, Los Angeles Institute of Contemporary Art. Curated by Jean-Luc Bordeaux. Catalog in French and English.
 Artists Space, New York.

1978
Drawing and Painting on Paper, Charlotte Crosby Kemper Gallery, Kansas City Art Institute, Missouri.

1979
New Work/September 1979, Hal Bromm Gallery, New York.

1980
Further Furniture, Marian Goodman Gallery, New York. Curated by Nicholas Calas and Marian Goodman.
Drawings, Leo Castelli Gallery, New York. Benefit for the Foundation for Contemporary Performing Arts.

1981
Thirty-Five Artists Return to Artists Space: A Benefit Exhibition, Artists Space, New York. Catalog.

1982
Louise Lawler, Allan McCollum, Sherrie Levine, The Eyelevel Gallery, Halifax, Nova Scotia.
Dark Thoughts: Black Paintings, Pratt Institute Gallery, New York. Curated by Ellen Schwartz.
Punctuated/Unpunctuated, The Grommet Gallery, New York. Curated by Marcia Hafif.
U.S. Art Now, Nordiska Kompaniet, Stockholm. Curated by Jan Eric Lowenadler.

1983
New York Now, Kester-Gesellschaft, Hanover. Curated by Dr. Carl Haenlein. Catalog in German.
The California Collection: Sixteen Paintings from the Gifford and Joann Phillips Collection, Museum of Fine Arts, Museum of New Mexico, Santa Fe, New Mexico.

1984
Ailleurs et Autrement, Musée d'Art Moderne de la Ville de Paris. Catalog with essay by Claude Gintz, in French.
Allan McCollum and James Welling, Cash/Newhouse Gallery, New York.
Artists' Call, Marian Goodman Gallery, New York.
Contemporary Perspectives, Center Gallery, Bucknell University, Lewisburg, Pennsylvania. Catalog with essay by Thomas Lawson.
A Different Climate: Aspects of Beauty in Contemporary Art, Städtische Kunsthalle, Düsseldorf. Curated by Jurgen Harten.
Natural Genre, Florida State University Fine Arts Gallery, Tallahassee. Catalog with essay by Collins and Milazzo.
POP, Spiritual America, New York. Curated by Richard Prince.
Re-place-ment, Hallwalls, Buffalo, New York. Curated by Robin Dodds.

1985
The Anticipated Ruin, The Kitchen, New York. Curated by Howard Halley.
Final Love, Cash/Newhouse Gallery, New York. Curated by Collins and Milazzo.
Persona Non Grata, Daniel Newburg Gallery, New York (with Laurie Simmons). Curated by Collins and Milazzo.
Americana, Whitney Museum of American Art, New York. Curated by Group Material for 1985 Biennial Exhibition. Catalog.
The Public Art Show, Nexus Contemporary Art Center, Atlanta. Curated by Ronald Jones. Catalog.

1985–86
A Life of Signs, Michael Klein, Inc., New York.
 Metro Pictures, New York.

1986
Damaged Goods: Desire and the Economy of the Object, The New Museum
 of Contemporary Art, New York. Catalog with artists' statements and
 essays by Deborah Bershad, Hal Foster, Marcia Tucker, and Brian
 Wallis.
Dissent: The Issue of Modern Art in Boston, Part III, "As Found," Institute
 of Contemporary Art, Boston. Catalog with essays by Benjamin
 Buchloh, Reinhold Heller, Serge Guilbaut, David Joselit, David Ross,
 and Elizabeth Sussman.
In the Tradition of: Photography 1915–1986, Light Gallery, New York.
MASS, The New Museum of Contemporary Art, New York. Curated by
 Group Material. Catalog with essays by William Olander and Group
 Material.
P, Gallery 303, New York.
Signs of Painting, Metro Pictures, New York.
Time after Time, Diane Brown Gallery, New York. Curated by Collins and
 Milazzo.
Rooted Rhetoric, Castel dell'Ovo, Naples. Curated by Gabriele Cuercio.
 Catalog with essays by Benjamin H. D. Buchloh, Joseph Kosuth,
 Thomas Lawson, Charles Le Vine, David Robbins, Angelo Trimarco, and
 Gabriele Cuercio, in Italian and English.
The Real Big Picture, Queens Museum, New York. Catalog with essay by
 Marvin Heiferman.
The Red Show, Massimo Audiello Gallery, New York. Curated by Robert
 Nickas.
Acceptable Entertainment, Bruno Faccetti Gallery, New York. Curated by
 Paul Laster and Renee Riccardo. Catalog with essay by Deborah
 Bershad.
Spiritual America, CEPA, Buffalo. Curated by Collins and Milazzo. Essay
 in CEPA quarterly by Collins and Milazzo.
Television's Impact on Contemporary Art, Queens Museum, New
 York. Curated by Marc H. Miller. Catalog.
Ultrasurd, S. L. Simpson Gallery, Toronto. Curated by Collins and
 Milazzo. Catalog.
Arts and Leisure, The Kitchen, New York, curated by Group Material.
 Catalog.

1986–87
Il Cagiante, Padiglione d'Arte Contemporanea, Milan. Curated by Corrado
 Levi. Catalog in Italian.

1987
Implosion: Et postmodernt perspektiv, Moderna Museet, Stockholm.
 Curated by Lars Nittve. Catalog with essays by Germano Celant, Kate
 Linker, Lars Nittve, and Craig Owens, in Swedish and English.
Photography and Art: Interactions Since 1946, Los Angeles County
 Museum of Art. Curated by Andy Grundberg and Kathleen
 McCarthy Gauss. Catalog.
Le Jour et la nuit, l'Orangerie du Château du Meudon, France. Curated
 by Le Coin du Miroir. Catalog with artist's statement, in French.
L'Objet de la peinture, École Superieure d'Art Visuel, Geneva. Curated by
 Catherine Quéloz. Catalog with essays by Catherine-Pier Favre,
 Catherine Quéloz, Ellen Versluis, Christine Weiss, and Vincent
 Vieck, in French.
Cadres en l'aire, Galerie d'Art et d'Essai, Bibliothèque Interuniversitaire,
 Université de Rennes, France.
Contemporary Photographic Portraiture, Musée Saint-Pierre d'Art
 Contemporain Lyon (with Laurie Simmons). Catalog with essay by
 Bernard Brunon, in French.
Avant-Garde in the Eighties, Los Angeles County Museum of Art. Curated
 by Howard Fox. Catalog.
The Castle, installation by Group Material at Documenta 8, Kassel,
 Germany.
New York Now, Israel Museum, Jerusalem. Curated by Suzanne Landau.
 Catalog in Hebrew.
Active Surplus: The Economy of the Object, The Power Plant, Toronto.
 Curated by Bruce Grenville. Catalog.
Armleder, Mosset, Rockenschaub, and McCollum, Galerie Sylvana Lorenz,
 Paris.
The Art of the Real, Galerie Pierre Huber, Geneva. Catalog with essay by
 Robert Nickas, in French.
Recent Tendencies in Black and White, Sidney Janis Gallery, New York.
 Curated by Jerry Saltz. Catalog.
Photographic Work from 1974–1987, Douglas Drake Gallery, New York.
The Ironic Sublime, Galerie Albrecht, Munich. Curated by Collins and
 Milazzo. Catalog in German.
The Spiral of Artificiality, Hallwalls, Buffalo. Curated by Paul Laster and
 Renee Riccardo. Catalog.
Selections from the John Weber Gallery, New York, Fay Gold Gallery,
 Atlanta.
Bronze, Plaster, and Polyester, Goldie Paley Gallery, Moore College of Art,
 Philadelphia. Curated by Elsa Weiner Longhauser. Catalog with essay
 by Wade Saunders.
The Hallucination of Truth, P.S. 1, Long Island City, New York (with
 Laurie Simmons). Curated by Paul Laster and Renee Riccardo.
Alan Belcher, Nancy Dwyer, and Allan McCollum, La Casa d'Arte, Milan.
 Sculptures, Galerie Charles Cartwright, Paris.
New York Art Now: The Saatchi Collection. Catalog with essay by Dan
 Cameron.

1987–88
Currents 12: Simulations New American Conceptualism, Milwaukee Art
 Museum. Curated by Dean Sobel. Brochure.

1988
Biennale di Venezia, Aperto, Venice. Catalog in Italian.
Allan McCollum/Richard Prince, Kunsthalle Zurich.
The Color Alone: The Monochrome Experiment, Musée Saint-Pierre d'Art
 Contemporain, Lyon. Catalog in French.
New York in View, Kunstverein München, Munich. Curated by Zdenek
 Felix. Catalog with essay by Noemi Smolik.
Une autre affaire, Le Consortium, Centre d'Art Contemporain, Dijon
 (with Louise Lawler).
Cultural Geometry, Deka Foundation House of Cyprus, Athens. Curated
 by Jeffrey Deitch. Catalog in Greek.
Alive/Survive: Amerikanische Kunst in K3, Kampnagelgelende, Hamburg.
 Curated by Janis Hendrickson. Catalog with essay by Janis
 Hendrickson, in German.
 John Weber Gallery, New York (with Franz Erhard Walther and
 Thomas Joshua Cooper).
Active Surplus, The Power Plant, Toronto. Curated by Bruce Grenville.
 Catalog and pamphlet.
Richard Artschwager: His Peers and Persuasion 1963–1988, Daniel
 Weinberg Gallery, Los Angeles; Leo Castelli Gallery, New York.
 Catalog with essay by Klaus Kertess.
Sculpture Parallels, Sidney Janis Gallery, New York.
A "Drawing" Show, Cable Gallery, New York. Curated by Jerry Saltz.
 Studio de l'Arc, Arles, France.

Two to Tango: Recent American Photography, International Center for
 Photography, New York (with Laurie Simmons).
Matrix, Mälmo Konsthall, Sweden. Catalog in Swedish.

1988–89
Art at the End of the Social, Rooseum, Mälmo, Sweden. Curated by Collins
 and Milazzo. Catalog.

1989
A Forest of Signs: Art in the Crisis of Representation, Museum of
 Contemporary Art, Los Angeles. Curated by Ann Goldstein and Mary
 Jane Jacob. Catalog with essays by Ann Goldstein, Mary Jane Jacob,
 Anne Rorimer, and Howard Singerman.
Bilderstreit: Widerspruch, Einheit und Fragment in der Kunst seit 1960,
 Museum Ludwig, Rheinhallen der Kölner Messe, Cologne. Curated
 by Siegfried Gohr, Johannes Gachnang, and Piet de Young. Catalog.
Contemporary American Sculpture: Signs of Life, Fundacao Calouste
 Gulbenkian, Lisbon. Curated by Judith Kirshner. Catalog in English
 and Portuguese.
 1989 Whitney Biennial Exhibition, Whitney Museum of American Art,
 New York. Catalog.
The Photography of Invention: American Pictures of the 1980's, The
 National Museum of American Art, Washington, D.C. Curated by
 Joshua Smith and Merry A. Foresta. Catalog with essay by Joshua
 Smith.
Cultural Medium, International Center for Photography, New York.
 Curated by Charles Stainback. Catalog.
The Desire of the Museum, Whitney Museum of American Art at Federal
 Reserve Plaza, New York. Curated by the Independent Study
 Program. Catalog with essays by Catsou Roberts, Timothy Landers,
 Marek Wieczorek, Jackie McCallister, and Benjamin Weil.
Conspicuous Display, Stedman Art Gallery, Rutgers University, Camden,
 New Jersey. Curated by Sid Sachs. Catalog.
Anti-Simulation: A Debate on Abstraction, Bertha and Karl Leubsdorf Art
 Gallery, Hunter College, New York, Curated by Maurice Berger.
 Catalog.
Departures: Photography 1924–1989, Hirschl and Adler Modern, New
 York. Catalog with essay by Simon Watney.
 Galerie Isabella Kacprzak, Cologne. Catalog with essays by Johannes
 Meinhardt and Jeffrey Rian, in German.
Art Collected: Private, Corporate and Museum Contexts, University Art
 Museum, Binghamton, New York. Curated by Lynn Gamwell.
Hybrid Neutral: Modes of Abstraction and the Social, Richard F. Brush Art
 Gallery, St. Lawrence Museum, New York. Traveling exhibition coor
 dinated by Independant Curators Incorporated. Curated by Collins
 and Milazzo. Catalog with essays by Collins and Milazzo and Gary
 Indiana.
Melancholia, Galerie Grita Insam, Vienna. Catalog in German.
Das Licht von der anderen Seite, PPS, Galerie F.C. Gundlach, Hamburg.
Small-Scale Work, Scott Hanson Gallery, New York.
80's International, Langer and Company, New York.
Mondi Possibili, La Casa d'Arte, Milan.
 Galerie Pierre Huber, Geneva.
Recent Acquisitions, Carl Solway Gallery, Cincinnati.
Buena Vista, John Gibson Gallery, New York. Curated by Collins and
 Milazzo. Catalog.

1989–90
Image World: Art and Media Culture, Whitney Museum of American Art,
 New York. Curated by Lisa Phillips, Marvin Heiferman, and John
 Hanhardt. Catalog.
The Play of the Unsayable, Wiener Secession, Vienna. Curated by Joseph
 Kosuth.
Laurie Simmons et Allan McCollum, Galerie Urbi et Orbi, Paris.
Group Show, Richard Kuhlenschmidt Gallery, Los Angeles.

1990
The Readymade Boomerang: Certain Relations in 20th Century Art, Sydney
 Biennale. Curated by Lynne Cooke, Rene Block, et al.
The Indomitable Spirit, International Center for Photography, New York.
 Curated by Marvin Heiferman; organized by Photographers and
 Friends against AIDS. Catalog with essay by Andy Grundberg and
 Marvin Heiferman.
Life-Size: A Sense of the Real in Recent Art, Israel Museum, Jerusalem.
 Catalog edited by Suzanne Landau, with essays by Douglas Crimp,
 Carolyn Cristov-Bakargiev, Germano Celant, Robert Storr, and
 Christian Leigh, in Hebrew and English.
Un art de la distinction, Abbaye Saint-André Centre d'Art Contemporain à
 Meymac, France. Catalog with essays by Jean-Paul Blanchet, Nicholas
 Bourriaud, Dan Cameron, and Xavier Girard, in French.
Against Interpretation (Towards a Non-Representational Photography),
 CEPA, Buffalo. Curated by Stephen Frailey.
Abstraction in Contemporary Photography, Emerson Gallery, Hamilton
 College, Richmond, Virginia. Curated by Jimmy DeSana. Catalog
 with essays by Andy Grundberg and Jerry Saltz.
La Collection des oeuvres photographiques du Musée de la Roche-sur-Yon,
 Musée de la Roche-sur-Yon. Catalog in French.
 Johnen and Schottle Gallery, Cologne.
Par Hazard, Douglas Drake Gallery, New York.
Taking the Picture: Photography and Appropriation, Leo Castelli, New
 York; Gallery Milano, Italy. Curated by Manuela Gandini. Catalog in
 Italian and English.
 Linda Farris Gallery, Seattle.
The Last Decade: American Artists of the 80's, Tony Shafrazi Gallery, New
 York. Curated by Collins and Milazzo with Diego Cortez. Catalog
 with essays by Collins and Milazzo, Diego Cortez, and Robert Pincus-
 Witten.
New York, New York, Galeria 57, Madrid.
IS '90 Exhibition, Washington, D.C.
Figures et Lectures, Galerie Samia Saouma, Paris.
Summer Group Show, John Weber Gallery, New York.
Strategies for the Last Painting, Jamie Wolff Gallery, New York; Feigen
 Incorporated, Chicago. Catalog with essay by Saul Ostrow.
Three Decades, The Oliver-Hoffmann Collection, Museum of
 Contemporary Art, Chicago. Catalog.
La Guerre de Troie n'aura pas lieu, Château d'Oiron, France.

1991
*Beyond the Frame: The Transition from Modernism to Postmodernism in
 American Art 1960–1990.* Curated by Lynn Gumpert. Setagaya Art
 Museum, Tokyo; The National Museum of Art, Osaka; Fukuoka Art
 Museum. Catalog in Japanese and English.
Objects for the Ideal Home: The Legacy of Pop Art, Serpentine Gallery,
 London. Catalog.
Zomeropstelling eigen collectie: nieuwe aanwinsten, Stedelijk van
 Abbemuseum, Eindhoven, Holland.
Vom Verschwinden der Dinge aus der Fotografie, Palais Liechtenstein,
 Vienna.
*Masterworks of Contemporary Sculpture, Painting and Drawing: The
 1930's to the 1990's,* Bellas Artes, Santa Fe, New Mexico.
Oeuvres originales, Fonds Régional d'Art Contemporain des Pays de la
 Loire, La Garenne Lemot Gétigné, Clisson, France.

Just What Is It That Makes Today's Homes So Different, So Appealing? The
 Hyde Collection, Glens Falls, New York. Curated by Dan Cameron.
 Catalog.
De-Persona, Oakland Museum, California.
Appropriation and Re-Photography, Fonds Régional d'Art Contemporain
 des Pays de la Loire, La Garenne Lemot Gétigné, Clisson, France.
Large Sculpture, John Weber Gallery, New York.
La Revanche de l'image, Galerie Pierre Huber, Geneva.
Media Culture, Studio Oggetto, Milan.
 Galerie Samuel Lallouz, Montreal.
Distribution: Random and Deliberate, Davis/McClain Gallery, Houston.
Works on Paper, Gallery 1709, St. Louis.
Three Rooms, Galerie Franck and Schulte, Berlin.
 Galeria Weber, Alexander y Cobo, Madrid.
Drawings, ARCO, Madrid. Organized by John Weber Gallery. Catalog.

1991–92
1991 Carnegie International. Curated by Lynne Cooke and Mark Francis.
 The Carnegie Museum of Art, Pittsburgh. Catalog with essay by
 Lynne Cooke and artist's interview.

1991–93
Departures: Photography 1923–1990. Curated by Edmund Yankov in con
 junction with Independent Curators Incorporated. Iris and B. Gerald
 Cantor Art Gallery, College of the Holy Cross, Worcester,
 Massachusetts; Denver Art Museum; Joslyn Art Museum, Omaha;
 Pittsburgh Center for the Arts; Goldie Paley Gallery, Moore College
 of Art and Design, Philadelphia; and Telfair Academy of Arts and
 Sciences, Savannah. Catalog.

1992
Allegories of Modernism: Contemporary Drawings, Museum of Modern Art,
 New York. Catalog with essay by Bernice Rose.
Repetition/Transformation, Museo Nacional de arte Reina Sofia, Madrid.
 Catalog with essays by Francisco Calva Serraller, Aurora Garcia, and
 Michael Tarantino, in English and Spanish.
C'est pas la fin du monde, Faux Movement; Galerie d'Art et d'Essai,
 Bibliothèque Interuniversitaire, Université de Rennes, France.
 Traveling exhibition. Catalog in French.
Overlay, Louver Gallery, New York.
Fifteenth Anniversary Exhibition, Rhona Hoffman Gallery, Chicago.
Theoretically Yours, Chiesa di san Lorenzo, Aosta, Italy. Curated by Collins
 and Milazzo. Catalog in Italian.
Drawings, Brooke Alexander Gallery, New York.
Selected Works from the Early Eighties, K—Raum Daxer, Munich. Catalog
 in German and English.
Functional Objects by Artists and Architects, Rhona Hoffman Gallery,
 Chicago.
 S. L. Simpson Gallery, Toronto.
 Galleri Faurschou, Copenhagen.
Points de vue et images du monde, Galerie Pierre Nouvion, Monte Carlo.

1993
Sculpture and Multiples, Brooke Alexander Gallery, New York.
Pirouettes, Olympic Collection 1994, Lillehammer Art Museum, Norway.
 Catalog in Norwegian.
Kunstruktionzitat, Sprengel Museum, Hanover. Catalog with essays by
 Thomas Weski and Stefan Iglhaut, in German.
Am Beispiel plastik: Konzeption und Form, Sprengel Museum, Hanover.
 Catalog in German.
Profil d'une galerie, Lieu d'Art Contemporain, Hameau-du-Lac, Siegnan,
 France.

1994
Desire and Loss, Carl Solway Gallery, Cincinnati.
Tuning Up, Kunstmuseum Wolfsburg, Germany.
*AURA: The Reality of the Artwork between Autonomy, Reproduction and
 Context,* Wiener Secession, Vienna. Curated by Markus Brüderlin. Catalog
 with essays by Markus Brüderlin, Harald Krämer, Johannes
 Meinhardt, Kathrin Rhomberg, and Theodora Bischer, in German
 and English.

1995
Critiques of Pure Abstraction, Independent Curators Incorporated, New
 York. Curated by Mark Rosenthal. Traveling exhibition. Catalog.
Summer Academy II, Pace Wildenstein, New York.
*The Reflected Image: A Selection of Contemporary Photography from the
 LAC Collection, Switzerland,* Luigi Pecci Museum for Contemporary Art,
 Prato, Italy. Catalog with essays by Antonella Soldaini, Paolo
 Colombo, Christopher Phillips, and Antonella Russo, in Italian and
 English.
Pittura/Immedia; Malerei in den 90er Jahren, Neue Galerie am
 Landesmuseum Joanneum und Kunstlerhaus, Graz, Austria. Curated
 by Peter Weibel. Catalog with essays by Peter Weibel and Thomas
 Dreher, in German.
L'objet. Fonds Régional d'Art Contemporain Rhône-Alps, La Villa du Parc,
 La Roche-sur-Foron. Catalog with essays by Thierry Chivrac, Jean-
 Pierre Keller, François-Bazzoli, and Marie-José Muller-Llorca, in
 French.
Articircolo Melnick 95, Melnick, Czechoslovakia. Curated by Jiri and
 Bettina Lobkowicz. Catalog in German, Czech, and English.

Selected Bibliography

1970
Sharp, Willoughby. "New Directions in Southern California Sculpture." *Arts Magazine,* September 1970, pp. 35–38.
Garver, Thomas. *Artforum* (review), December 1970.

1971
Plagens, Peter. "Los Angeles: New Painting in Los Angeles." *Artforum,* October 1971, pp. 86–90.

1972
Plagens, Peter. "The Decline and Rise of Younger Los Angeles Art." *Artforum,* May 1972, pp. 72–81.

1973
Plagens, Peter. "From School Painting to a School of Painting in Los Angeles." *Art in America,* March/April 1973, pp. 36–41.

1974
Plagens, Peter. *Sunshine Muse: Contemporary Art on the West Coast.* New York: Praeger, 1974.

1975
McCollum, Allan. "Painters Reply." *Artforum,* September 1975, pp. 26–36.
Rosenberg, Harold. *Art on the Edge.* New York: MacMillan, 1975.

1979
Masheck, Joseph. "Iconicity." *Artforum,* January 1979, pp. 30–41.

1980
Zimmer, Bill. "Jenny Snider, Jeff Balsmeyer, Allan McCollum, Silvia Kolbowski, Richard Prince" (review of Artists Space exhibition). *Soho Weekly News,* March 12, 1980, p. 50.
Cornu, Daniel. "Review: Galerie Yvon Lambert Exhibition." *Art Press,* June 1980, p. 35, in French.
Bell, Jane. *Art News* (review of Artists Space exhibition). September 1980, p. 252.
McCollum, Allan. "Matt Mullican's World." *Real Life Magazine,* Winter 1980, pp. 4–13.

1981
Lawson, Thomas. "Further Furniture." *Artforum,* March 1981, pp. 82–83.

1983
Lawson, Thomas. "Review: Marian Goodman Gallery Exhibition." *Artforum,* March 1983, pp. 82–83.
McCollum, Allan. "False Pictures." *Effects,* Summer 1983, p. 18.
McMahon, Paul. "From the Permanent Collection." *Real Life Magazine,* Summer 1983, pp. 12–15.
Smith, Valerie. "Review: Marian Goodman Gallery Exhibit." *Flash Art,* Summer 1983, p. 65.
Lawson, Thomas. "Reviews: New York." *Artforum,* September 1983, pp. 70–71.
Owens, Craig. "Allan McCollum: Repetition and Difference." *Art in America,* September 1983, pp. 130–32.

1984
McCollum, Allan. "Reciprocal Surveillance." *Effects,* 1984, p. 7.
Lichtenstein, Therese. "Reviews: Allan McCollum/James Welling." *Arts Magazine,* Summer 1984, p. 44.
Lichtenstein, Therese. "Allan McCollum and Louise Lawler." *Arts Magazine,* December 1984, p. 34.
McCollum, Allan. *New Observations,* 1984, p. 8 (project with Louise Lawler).

1985
McCollum, Allan. "In the Collection of . . ." *Wedge,* Winter/Spring 1985, pp. 62–67.
Durand, Regis. "New York Ailleurs et Autrement: Interview with Claude Gintz." Art Press 88 (January 1985), pp. 20–22, in French.
Linker, Kate. "Reviews: New York." *Artforum,* January 1985, p. 87.
Collins, Tricia, and Richard Milazzo. "Total Effect." *Zien Magazine,* no. 8 (1985), pp. 21–22.
Owens, Craig. "Herhaling and Verschil." *The Museum Journal,* no. 10 (1985), pp. 291–94, in Dutch.
Robbins, D. A., "An Interview with Allan McCollum." *Arts Magazine,* October 1985, pp. 40–44.
Godfrey, T., "Allan McCollum." *Burlington Magazine,* December 1985, p. 925.
Heartney, Eleanor. "New York Reviews: Allan McCollum and Laurie Simmons." *Art News,* December 1985, p. 127.
Staniszewski, Mary Anne. "Fixing Prices." *Manhattan Inc.,* December 1985, pp. 145–49.
Masheck, Joseph. "Series: 'Point. Art Visual/Visual Arts,' " in *Smart Art.* New York: Willis Locker and Owners, 1985.
Milazzo, Richard. *Beauty and Critique.* New York: Mussman Bruce, 1985.
Wallis, Brian. *Art after Modernism: Rethinking Representation.* Boston: David Godine, 1985.

1985–86
Biegler, Beth. "Surrogates and Stereotypes" (interview with Allan McCollum and Laurie Simmons). *East Village Eye,* December 1985/January 1986, pp. 43, 64.
Morgan, Susan. "Allan McCollum and Laurie Simmons." *Artscribe,* December 1985/January 1986, pp. 82–83.
Watson, Gray. "Interview with Allan McCollum." *Artscribe,* December 1985/January 1986, pp. 65–67.

1986
Smith, Roberta. "Allan McCollum and Laurie Simmons at Nature Morte," *Art in America,* January 1986.
Collum, J. W. "Actual Photos: Allan McCollum and Laurie Simmons." *Art Papers,* January/February 1986, pp. 63–64.
Mahoney, Robert. "Review at Diane Brown Gallery." *Arts Magazine,* March 1986, p. 138.
Meinhardt, Johannes. "Allan McCollum: Surrogates" (review). *Kunstforum,* March/April 1986, pp. 278–79, in German.
Jones, Ronald. "Six Artists at the End of the Line: Gretchen Bender, Ashley Bickerton, Peter Halley, Louise Lawler, Allan McCollum and Peter Nagy." *Arts Magazine,* May 1986, pp. 49–51.
Collins, Tricia, and Richard Milazzo. "Szene New York: Allan McCollum, the Blank Spectacle." *Kunstforum,* June/August 1986, pp. 314–416, in German.
Indiana, Gary. "Rooted Rhetoric" (review of exhibition at Castel dell'Ovo). *Flash Art,* October/November 1986, pp. 83–84.
Jones, Ronald. "Damaged Goods" (review of exhibition at the New Museum of Contemporary Art). *Flash Art,* October/November 1986, pp. 75–76.
Beyond Boundaries: New York's New Art. Essays by Peter Halley and Roberta Smith. New York: Alfred van der Marck Editions, 1986.
Foster, Hal. *Recoding: Art, Spectacle, Cultural Politics.* Seattle: Bay Press, 1986.

1986–87
Brooks, Rosetta. "Space Fictions." *Flash Art,* December 1986/January 1987, pp.78–80.
Salvioni, Daniela. "Interview with McCollum and Koons." *Flash Art,* December 1986/ January 1987, pp. 66–68.

1987
Heartney, Eleanor. "Simulationism." *Artnews,* January 1987, pp. 130–37.
"Perfect Vehicles." *Spazio Umano/Human Space,* January 1987, pp. 90–94, in Italian.
Miller, John. "What You See Is What You Don't Get: Allan McCollum's Surrogates, Perpetual Photos and Perfect Vehicles." *Artscribe,* January/ February 1987, pp. 32-36.
Brooks, Rosetta. "Art and Its Double: A New York Perspective." *Flash Art,* May 1987, pp. 57–72.
Kent, Sarah. "Allan McCollum, Art and Language" (review of exhibition at Lisson Gallery). *Time Out,* May 13, 1987, p. 40.
Jones, Ronald. "As Though We Knew What to Do." *C Magazine,* Summer 1987, pp. 35–37.
Cameron, Dan. "New American Art." *Art and Design* 3, no. 9/10 (1987), pp. 33–36.
Cooke, Lynne. "Object Lessons." *Artscribe,* September/October 1987, pp. 55–60.
Collins, Tricia, and Richard Milazzo. "Radical Consumption and the New Poverty: A Discourse on Irony and Superfluity." *New Observations,* no. 51 (October 1987), pp. 7, 12–13.
Brollo, Boris. "Allan McCollum." *Juliet Art Magazine,* October/November 1987, p. 37, in Italian.
Cameron, Dan. "The Art of the Real." *Tema Celeste,* November 1987, pp. 80, 97–98.
Zaunschirm, Thomas, and Alexander Puhringer. "Neokonzeptionalismus Szene New York." *Noema Art Magazine,* no. 11 (1987), pp. 18–38, in German.
Cameron, Dan. *New York Art Now: The Saatchi Collection.* London: The Saatchi Museum; Giancarlo Politi Editore, 1987.

1988
Pelenc, Arielle. "La Consommation de l'art ou l'art de la consommation." *Art Press,* no. 128, pp. 26–30, in French.
Smith, Roberta. "Allan McCollum" (review of exhibition at John Weber Gallery). *New York Times,* February 19, 1988.
McGill, Douglas C. "Allan McCollum: Repetitive Sculptures." *New York Times,* February 26, 1988.
Gintz, Claude. "Allan McCollum: Perfect Vehicles" (review of exhibition at Galerie Yvon Lambert). *Art Press* 123 (March 1988), p. 70, in French.
Fraser, Andrea. "Individual Works." *Faces,* no. 9 (Spring 1988), pp. 26–29, in French.
Fraser, Andrea, and Catherine Quéloz. "Indices de Culture: Allan McCollum et Richard Prince." *Faces,* no. 9 (Spring 1988), pp. 26–33, in French.
Quéloz, Catherine. "Comment énumérer les vertus d'une oeuvre d'art n'im porte qui pourrait posséder?" *Faces,* no. 9 (Spring 1988), pp. 29–33, in French.
Cotter, Holland. "Allan McCollum at Julian Pretto, Annina Nosei and John Weber" (review). *Art in America,* April 1988, pp. 203, 204.
Heartney, Eleanor. "Allan McCollum" (review of exhibition at John Weber Gallery and Annina Nosei Gallery). *Art News,* May 1988, pp. 164–65.
Miller, John. "Allan McCollum: John Weber Gallery" (review). *Artforum,* May 1988, p. 139.
Salvioni, Daniela. "Allan McCollum" (review of exhibition at John Weber Gallery). *Flash Art,* May/June 1988, p. 127.
Gablik, Suzi. "Dancing with Baudrillard." *Art in America,* June 1988, p. 27.
Handy, Ellen. "Allan McCollum" (review of exhibition at John Weber Gallery and Annina Nosei Gallery). *Arts Magazine,* Summer 1988, p.111.
Schenker, Christoph. "Allan McCollum/Richard Prince." *Noema Art Magazine,* September/October 1988, pp. 82–83, in German.
Bourriaud, Nicolas. "L'Aura de McCollum." *New Art International,* October/November 1988, pp. 68–72, in French.
Celant, Germano. *Unexpressionism: Art Beyond the Contemporary.* New York: Rizzoli, 1988.

1989
Ball, Edward. "The Beautiful Language of My Century." *Arts Magazine,* January 1989, pp. 65–72.
Stals, J. Lebrero. "Allan McCollum." *Lapiz International* 6, no. 57 (March 1989), p. 69, in Spanish.
Vogel, Sabine. "Allan McCollum: Individual Works." *Wolkenkratzer Art Magazine,* March 1989, pp. 78–81, in German.
Meinhardt, Johannes. "Ersatzobjeckte und bedeutende Rahmen: Allan McCollum, Louise Lawler, Barbara Bloom." *Kunstforum,* March/April 1989, pp. 200–20, in German.
Durand, Regis. "Allan McCollum and Laurie Simmons" (review). *Art Press,* May 1989, p. 66, in French.
Knight, Christopher. "McCollum's 'Perfect Vehicle' Shifts to High Gear." *Los Angeles Herald-Examiner,* May 25, 1989.

Leigh, Christian, Tazami Shinoda, and Yasushi Kurabayashi. "The Whitney Biennial 1989." *Bijutsu Techo,* July 1989, pp. 157–77.
Sterckx, Pierre. "Les Véhicules parfaits d'Allan McCollum." *Art Press,* no. 138 (July/August 1989), in French.
Kandel, Susan. "Allan McCollum" (review of exhibition at Richard Kuhlenschmidt Gallery). *Art Issues,* September/October 1989, p. 21.
Collins, Tricia, and Richard Milazzo. "Quantity and Immanence: Allan McCollum" (interview with artist). *Tema Celeste,* October/December 1989, pp. 54–56.
Collins, Tricia, and Richard Milazzo. Hyperframes: *A Post-Appropriation Discourse,* vol. 1. Paris: Editions Antoine Candau, 1989.
Robbins, David. *The Camera Believes Everything.* Stuttgart: Editions Patricia Schwartz, 1989.

1990
Celant, Germano. "Unexpressionism." *New Art International,* 1990.
Roskam, Mathilde. "Allan McCollum at the van Abbemuseum, Eindhoven." *Flash Art,* January/February 1990, pp. 143–44.
Quéloz, Catherine. "Allan McCollum." *Beaux-Arts,* February 1990, pp. 106–7, in French.
Power, Kevin. *Artes and Leiloes* (interview with artist). February/March 1990, pp.75–80, in Portuguese.
Kent, Sarah. "Art or Artefact?" *Time Out,* March 21–28, 1990.
Grundberg, Andy. "Allan McCollum." *New York Times,* March 23, 1990.
Pietsch, Hans. "London: Allan McCollum" (review). *Art: Das Kunstmagazine,* April 1990, in German.
Vogel, Sabine B. "Allan McCollum a Stedelijk van Abbemuseum, *Contemporanea,* April 1990, p. 99, in German.
Ward, Frazer. "Allan McCollum, Drawings" (review). Art and Text, August 1990.
Gillick, Liam. "Allan McCollum, Serpentine" (review). *Artscribe,* Summer 1990, pp. 73–74.
Shottenkirk, Dena. "Allan McCollum" (review of exhibition at John Weber Gallery). *Artforum,* Summer 1990, pp. 164–65.
Spears, Dorothy. "Allan McCollum" (review of exhibition at John Weber Gallery). *Arts Magazine,* Summer 1990, p. 79.
Morsiani, Paola. *Juliet* (review), October/November 1990, pp. 58–59, in Italian.
Papadakis, Andreas, Clare Farrow, and Nicole Hodges. *New Art.* New York: St. Martin's Press, 1990.
New Art. Edited by Phyllis Freeman, Mark Greenberg, Eric Himmel, Andreas Landshoff, and Charles Miers. New York: Harry N. Abrams, Inc., 1990.

1991
Art (Hamburg), January 1991, p. 101, in German.
Rimanelli, David. "Openings: Andrea Fraser." Artforum, Summer 1991, p. 106.
Kimmelman, Michael. "At Carnegie 1991: Sincerity Edges Out Irony." *New York Times,* October 27, 1991, pp. 31, 34.
Gablik, Suzi. *The Reenchantment of Art.* London: Thames and Hudson, 1991.

1992
Wetzel, Michael. "Dealing with Things." *Camera Austria* 38 (1992), pp. 23–40, in German.
Jinker-Lloyd, Amy. "Musing on Museology." *Art in America,* June 1992, pp. 47–51.
Kalina, Richard. "Lost and Found." *Art in America,* June 1992, pp. 99–101.
Owens, Craig. *Beyond Recognition: Representation, Power, and Culture.* Berkeley: University of California Press, 1992.
Martin, J., et al. *L'Art des États-Unis.* Paris: Citadelles and Mazenod, 1992, in French.

1993
Bartels, Daghild. "Allan McCollum, Pieter Laurens Mol: Centre d'Art Contemporain, Geneva." *Artis,* 1993.
Meinhardt, Johannes. "Allan McCollum." *Kunstforum* 123 (1993), pp.184–87, in German.
Saunders, Wade. "Making Art, Making Artists" (includes interview with artist). *Art in America,* January 1993, pp. 93–95.
Cooke, Lynne. "Natural Casts: Recent Work by Allan McCollum." *Archis,* February 1993, pp. 26–35.
Masséra, Jean-Charles. "Allan McCollum: The Dog from Pompeii" (review of exhibition at John Weber Gallery). *Art Press,* February 1993, p. 86, in French.
Tager, Alexandra. "Geneva Opens Its Doors." *Art and Auction,* March 1993, pp. 24–26.
Kastner, Jeffrey. "Allan McCollum, Centre d'Art Contemporain." *Frieze,* May 1993, p. 52.
Mollica, Franco. "Allan McCollum." *Tema Celesta,* June 1993, p. 72, in Italian.
Perretta, Gabriele. "Allan McCollum." *Flash Art,* June 1993, p. 95, in Italian.
Rosengarten, Ruth. "Perpetual Photographs." *Visão* 8 (July 1993), p. 91, in Portuguese.
Melo, Alexandre. "Allan McCollum." *Expresso,* July 17, 1993, in Portuguese.
Janus, Elizabeth. *Artis* (review of exhibition at Centre d'Art Contemporain), Fall 1993, pp. 204–5.
Papineau, June. *C Magazine* (review of exhibition at Centre d'Art Contemporain) 39 (Fall 1993), pp. 58–59, in Portuguese.
Becket, Wendy. *The Gaze of Love.* London: HarperCollins, 1993.

1994
Rorimer, Anne. "Allan McCollum: Systeme ästhetischer und (Massen-) Produktion." *Kunstforum,* January–February 1994, pp. 136–40, in German.

1995
Decter, Joshua. "Allan McCollum: Natural Copies" (review of exhibition at John Weber Gallery). *Artforum,* Summer 1995, p. 104.
Melrod, George. "Reviews: New York" (review of exhibition at John Weber Gallery). *Sculpture,* July/August 1995, p. 40.
Staniszewski, Mary Anne. *Believing Is Seeing: Creating the Culture of Art.* New York: Penguin Books USA.